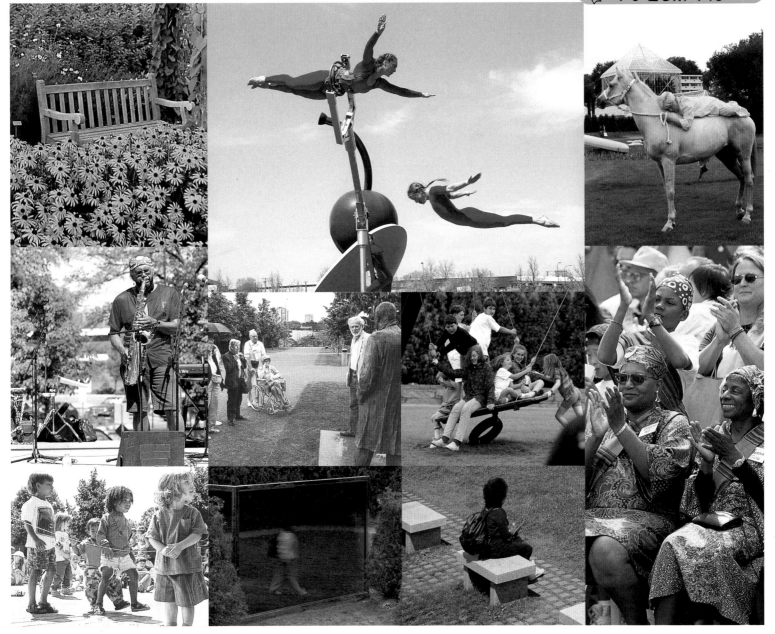

THIS PUBLICATION WAS MADE POSSIBLE BY A GENEROUS GRANT FROM

DAYTON'S

PRODUCTION AND MANAGEMENT ASSISTANCE FROM MSP CUSTOM COMMUNICATIONS
IN-KIND CONTRIBUTIONS FROM APPLETON PAPERS

© 1998 WALKER ART CENTER, MINNEAPOLIS

ISBN 0-935640-65-7

PRINTED IN THE UNITED STATES OF AMERICA BY AMBASSADOR PRESS, INC., MINNEAPOLIS
DESIGN: GRAPHIC DESIGN FOR LOVE (+$)
RESEARCH AND EDITORIAL: JANET JENKINS
BUSINESS MANAGEMENT: NANCY PERLMAN
PHOTOGRAPHS: UNLESS OTHERWISE CREDITED, ALL PHOTOGRAPHS BY GLENN HALVORSON, DAN DENNEHY, AND BARBARA ECONOMON FOR WALKER ART CENTER

MINNEAPOLIS

A COLLABORATION BETWEEN

THE WALKER ART CENTER

AND THE MINNEAPOLIS PARK AND RECREATION BOARD

SCULPTURE
GARDEN

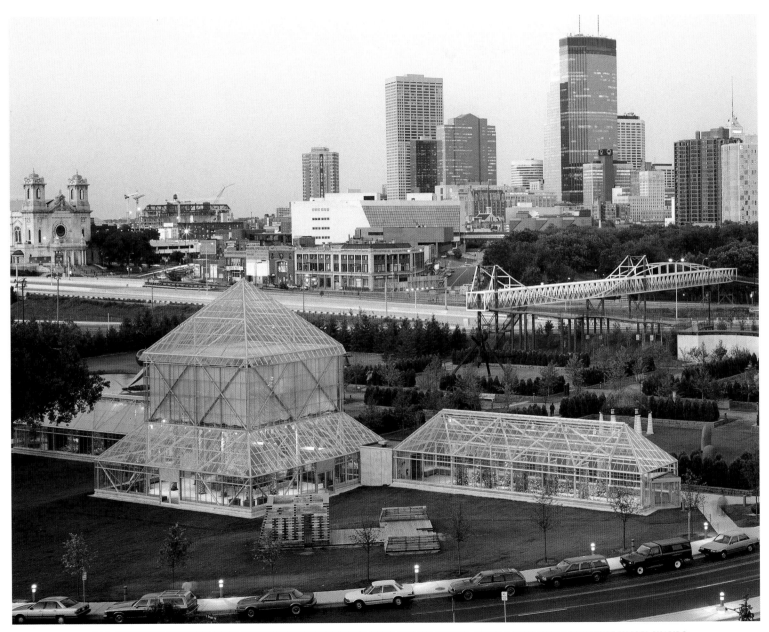

ABOVE: THE COWLES CONSERVATORY AND MINNEAPOLIS SCULPTURE GARDEN MEET THE CITY'S SKYLINE AT DUSK *RIGHT*: A ROMP WITH A SCULPTURE BY JOEL SHAPIRO

THE GARDEN
IN THE CITY

REFLECTIONS FROM
THE DIRECTOR

If the building of the Minneapolis Sculpture Garden is a tale of unprecedented civic achievement, the first ten years of its existence is a love story. More than three million people have visited the Garden over these years, strolling its broad avenues and curving walkways to discover a new work of art or a peaceful haven in the urban landscape. It has even played host to many a wedding celebration. The city itself has embraced the Garden as a symbol of its vital cultural life and remarkable system of green spaces, and several of the artworks have become veritable icons in the urban identity. What visitor to Minneapolis does not return home without a carefully posed snapshot in front of Claes Oldenburg and Coosje van Bruggen's joyful *Spoonbridge and Cherry?* How many families have brought their children to the Garden on a weekend afternoon to enjoy a performance or interactive workshop, or simply to witness the look of discovery on their faces as they encounter a new shape or texture? What elementary school group, during its tour of the sculptures, has not generated some creative musings of its own? After a mere ten years, there is a sense that the Garden is an amenity that has been here forever, and one that the city could never have done without.

The existence of the Garden is due largely to the vision of a single individual: Martin Friedman, who nurtured the Walker Art Center as its director for nearly thirty years and brought it to international prominence as a model for the multidisciplinary presentation of contemporary art. But even Martin's tenacious vision, exacting eye, and boundless energy—in tandem with Mickey Friedman's design expertise—could not have accomplished this task alone. It would take the unparalleled cooperation of a host of institutions and individuals to bring the project to fruition. In addition to the museum, these partners have included the Minneapolis Park and Recreation Board, whose superintendent, David Fisher, worked hand-in-hand with Martin and the staffs of both institutions; a team of artists and distinguished architects and landscape designers, whose contributions are outlined later in this book; the city of Minneapolis, which provided the materials and services to modify the street between the Walker and the new Garden space; the University of Minnesota Landscape Arboretum, which assisted with the horticultural displays during the early years; and a group of individuals, foundations, and corporations, listed individually at the end of this volume, whose generosity and foresight made the entire undertaking a reality.

Special mention must be made of the McKnight Foundation, which initiated the project with a magnanimous contribution in 1984; Judy and Kenneth Dayton, longtime supporters of the museum and of contemporary art, who continue to enliven the Garden through purchases of new artworks; Sage and John Cowles, who generously funded the construction of the Garden's glass Conservatory; the family of Irene Hixon Whitney, who made possible the commission of Siah Armajani's visionary bridge; Frederick R. Weisman, who made the the commission of the *Spoonbridge and Cherry* and a number of other sculptures possible; the Regis Corporation, which has funded the changing displays of horticulture in the Conservatory; and the N. Bud Grossman family, who underwrote the construction of the glorious Alene Grossman Memorial Arbor and Flower Garden. The Bush, Cargill, Dayton Hudson, General Mills, Honeywell, and Kresge foundations also must be noted for their spirited support.

A number of things make the Minneapolis Sculpture Garden unique. It is the largest urban sculpture garden in the nation. It offers year-round access to its visitors, with extensive hours that have made it a feature of the city's nightlife as well as its days. It has been lauded as the finest showcase for the display of contemporary sculpture in the country. But perhaps the most unusual aspect of the Garden is the partnership that has been forged, in an historic 25-year agreement, between the two institutions responsible for its programs and operations, the Walker Art Center and the Minneapolis Park and Recreation Board, both venerable organizations in their own rights.

The Minneapolis park system is comprised of some 6,000 acres of land; 170 parks and green spaces, none further than six blocks from any home within the city's limits; 38 miles of walking and bicycle trails; a 55-mile "emerald necklace" of parkways; and a much beloved "chain of lakes." According to an article in the June 8, 1998, issue of *U. S. News and World Report,* its unmatched reputation is due both to the city's founders, who wisely set aside extensive properties for public use, and to the historically independent Park Board, which has ensured adequate funding and pristine stewardship of the land over these many years. Its expert management of the grounds, plantings, pathways, and greenhouses of the Garden has been an essential complement to the Walker's curatorial and educational efforts. With the help of both institutions, the Garden has reconnected the parklands of the city, from the Mississippi riverfront to the lake district. Its true success, according to Paul Goldberger of the *New York Times,* is that it is a "link in a complex chain of urban events—not an isolated place unto itself."

From the beginning, the Garden was envisioned as a space in which works of the modern masters—Henry Moore, Isamu Noguchi, Jacques Lipchitz—would stand side by side with the explorations of younger artists, both in permanent and temporary installations. To this end, the Garden is a living, growing organism: its roots are planted firmly in the soil, even as it reaches out to grow in new directions. New acquisitions and temporary exhibitions of significant recent work are ongoing priorities for the museum, as are the many lively performances, readings, and educational events for people of all ages that take place within its spaces. In the fall of 1998, the museum will unveil a new project, funded by the Medtronic Foundation, by the young Dutch artist Joep van Lieshout. Together with his associates and members of the community, he will create a unique, two-part structure for the Garden: a life-size wooden house with a detachable mobile unit that will move through the neighborhoods of the city, providing an arena for arts activities and community projects. Sculpture has changed greatly since Saul Baizerman hammered his graceful *Nike* out of a sheet of copper at mid-century, and even since Tony Smith and Richard Serra created their elegant, Minimal works in the sixties and seventies. But change though it may, one thing remains constant about contemporary sculpture: it continues to draw people into important experiences—both intimate and communal—with materials, shapes, functions, and meanings.

The city of Minneapolis and its people, as well as visitors from across the world, have embraced the Garden as a space for contemplation and for celebration. Vital cultural activities have emerged from within the walls of the museum and moved to the grassy outdoor spaces. The outdoors, in turn, has offered up its beauty as a home for important works of art. It is a happy alliance. Watch your Garden grow and visit again soon.

Kathy Halbreich
Director, Walker Art Center

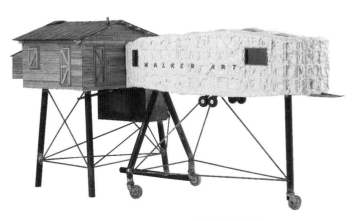

MODEL FOR JOEP VAN LIESHOUT'S
NEW GARDEN PROJECT

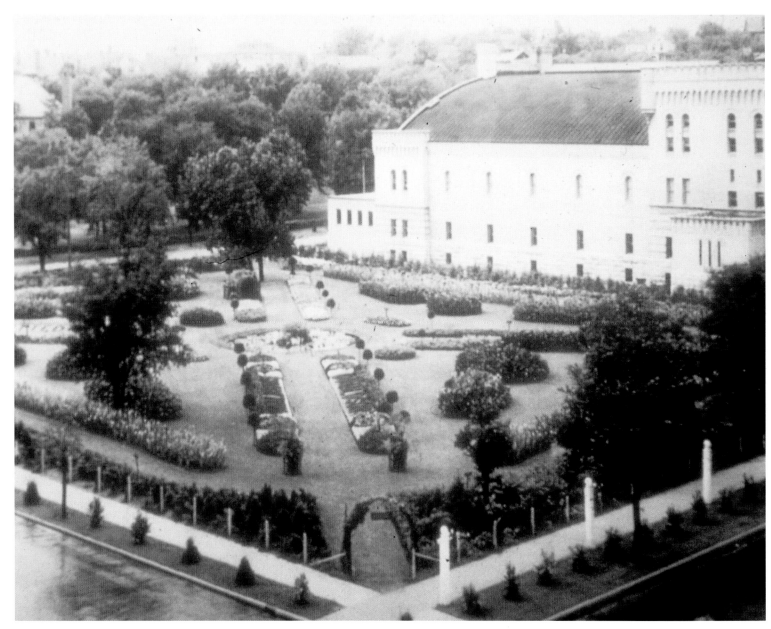

THE KENWOOD ARMORY AND ADJACENT GARDENS, CIRCA 1915; PHOTO COURTESY MINNESOTA HISTORICAL SOCIETY

The story of the parcel of land on which the Minneapolis Sculpture Garden sits is every bit as colorful as the sculptures that now grace its verdant spaces. By turns amusing and somber, lively with controversy or frustratingly slow to move, it is a story, above all, that begins and ends with the city and its people.

It was more than a hundred years ago, in 1893, that the city acquired the first piece of land on what would come to be known for many years as "The Parade"—even after the military drills and exercises that once took place on its grounds had long passed from the public's memory. The ten-acre tract, acquired for $99,750, was at first named Spring Lake Park and soon after Hiyata Park. A swampy mixture of peat bogs and quicksand, it shortly was joined by surrounding parcels of land, bought up by the city and some of its prominent citizens to be set aside for public use. By the turn of the century, a portion of the site was in use as a winter haven for the birds and fowl from the zoo at Minnehaha Falls, and in 1904, construction began on a $350,000 Armory to house the 13th Regiment Spanish War Volunteers. The project was ill-fated from its inception. Despite the unstable conditions of the land, it was filled, graded, and seeded, and the cornerstone of the massive, pseudo-Romanesque "Kenwood Armory" was laid in the summer of 1905. Central to the building was a vast, 150-foot-square drill hall surmounted by a great steel-arched roof with glass skylights. A gallery surrounding the hall housed company rooms, a gymnasium, gun room, regimental band room, and rifle range, while the third floor boasted a dance hall with stage, commodious banquet room, and kitchens. By December of the same year, the building—not yet completed—already had been condemned.

100 YEARS
AT THE
PARADE
A HISTORY OF
THE GARDEN SITE

The year 1906 saw the firing of the original contractor, refashioning of the concrete work, and even a flurry of concern from the humane societies over the sparrows that had become entrapped in the structure. But disintegration was already beginning to set in as the piles continued to settle in the spongy soil. Nonetheless, the building was dedicated the following January, with four companies of the national guard leading the celebratory parade. By early spring, the Armory played host to the first of many public events that would be held there: the inaugural Minneapolis Automobile Show, staged by a local car dealer. In 1913 the Society of American Florists and Ornamental Horticulturists held its annual convention at the site. Growers from across the country were invited to send bulbs, seeds, and plants for exhibition, and a demonstration garden was created on the adjacent lands. As Theodore Wirth, visionary superintendent of the city's parks from 1906 to 1935, later recounted in his book *Minneapolis Park System 1883–1944*, the gardens were an attempt to prove "that the Minnesota climate is not so adverse to successful achievements in floriculture as some people from other parts of the country are inclined to believe." The gardens were so successful, in fact, that they were retained permanently—that is, until the construction of Interstate 94 some fifty years later demanded easements from the surrounding lands, and the beloved flower beds of the "Armory Gardens" were removed for good.

During the intervening years, however, the public continued to enjoy weekend strolls in the gardens. In 1914, the first commercial baseball league play took place on the grounds, initiating a rich tradition of sports-related activities on the site that would come to include public softball fields and, for many years, the area's only lighted football stadium. But by World War I, the Armory itself had become a pitiful white elephant. The home guard stored its equipment there but, for fear of rattling the already tenuous structure, was forced to drill elsewhere. The military's loss, however, was the public's gain as the site played host in the postwar years to a series of dances, concerts, and even prize fights. In 1920, the public witnessed a world record for commercial air-freight transportation, as two pilots from New York, carrying merchandise destined for the Dayton Company, landed at the Parade grounds after a 1,600-mile flight from Long Island. Great musicians of the day played the site: soprano Amelita Galli-Curci and tenor Roland Hayes, violinist Jascha Heifetz, and bandmaster-composer John Philip Sousa. The area gained a further cultural dimension in 1927, when Minneapolis lumberman and civic leader Thomas Barlow Walker opened the Walker Art Gallery in a fanciful Hispano-moresque edifice on the site opposite the Armory grounds. The building housed his eclectic collection of nineteenth-century paintings, Chinese jade and ceramics, American Indian pottery, and European decorative art objects.

In 1929, the stock market was not the only institution to crash. That same year, the Military Agencies Committee reported that the Armory, too, was in danger of "immediate collapse." Vacated and of no further use to the military, it was razed with great blasts of dynamite at the end of 1933, as the first chapter of the land's history came to a definitive close. The remains of the site were shocking: workmen found no less than four successive concrete floors built one on top of the other. In a mere thirty years, the building had sunk some fifty-three inches into the boggy soil. In 1935, a new Armory was built in downtown Minneapolis, between Fifth and Sixth Streets, and ownership of the old Kenwood Armory site was passed to the Minneapolis Park Board. The land would continue to be known popularly as the "Armory Gardens" for many years, until 1967, when the beautifully maintained floral beds and hedges were removed permanently. All that would remain of the grounds across from the Walker Art Center and Guthrie Theater, its neighbor since 1963, was an undeveloped field.

By this time, the Walker's holdings in twentieth-century art had grown significantly, both in number and sheer size, and in 1971, a new building was erected on the site. During these years, the museum's director, Martin Friedman, kept a watchful eye on the vacant land across the street. Sometimes the museum was granted use of the space for the installation of large-scale sculptures, on a project-by-project basis. But it was a wholly unanticipated public controversy over the planned placement of an ornamental fountain on the site that eventually brought together civic groups, cultural institutions, and city agencies to consider the ultimate future of the grounds. The dandelion-shaped fountain was eventually installed in a location at the east end of Loring Park, but a new relationship between the Park Board and the Walker had begun to build. Together, the boards and staffs of the two institutions developed plans for a large-scale sculpture garden that would bring the glory days of the old Armory Gardens back to the public—this time, on a scale no other urban park in the nation could match.

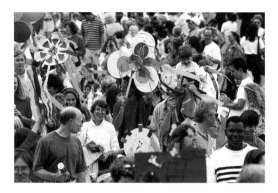

The Minneapolis Sculpture Garden opened on September 10, 1988, with a gala ribbon-cutting ceremony and 10,000 balloons launched into the skies. In attendance were Governor Rudy Perpich and Mayor Donald M. Fraser, a marching band, a spoon band, a quartet of jazz vocalists, and a brass quintet from the Minnesota Orchestra. In addition to the new works of art in the Garden and tours of the horticultural displays, visitors were able to view the work of seventeen young sculptors presented in the exhibition *Sculpture Inside Outside,* which continued into the museum's galleries. Immediately embraced by the public and lauded by art and architectural critics, the Garden received more than 500,000 visitors in its first year.

But the planning wasn't over. From the beginning, Friedman had set his sights on expanding the Garden to include the area to its north, then occupied by softball fields. In 1990, Parade Stadium, host to hundreds of Friday-night football games in its former days, was torn down, and plans to move the softball fields to this site just west of the Garden were finalized. It was also in this year that Friedman, after twenty-nine years as head of the museum, retired. The execution of the Garden expansion came to fruition under the tutelage of the Walker's new director, Kathy Halbreich—as ever, working closely with longtime partner Dave Fisher, Superintendent of the Minneapolis Park and Recreation Board. The new Garden expansion opened on September 12, 1992, with a day-long celebration that included parades, workshops, and performances, and an indoor exhibition, *Claes Oldenburg: In the Studio.*

Reconnected to the city and to its people, the Garden continues to grow. Where once the great singers of the day performed, concerts of new music and dance take place among the growing collection of artworks and changing displays of plants and flowers. The dreams of the city's early planners have been restored.

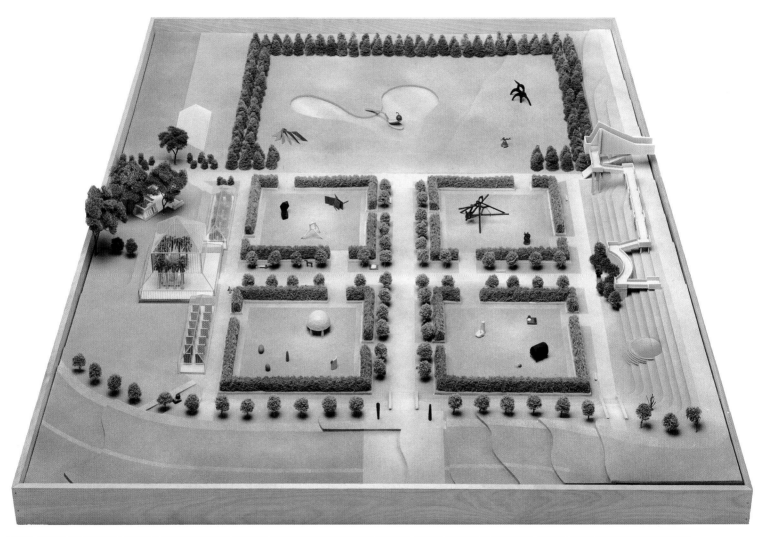

ABOVE: MODEL OF EDWARD LARRABEE BARNES'S DESIGN FOR THE MINNEAPOLIS SCULPTURE GARDEN *RIGHT:* WALKER ART CENTER, VIEWED FROM THE GARDEN GROUNDS

BUILDING THE GARDEN

DESIGN AND ARCHITECTURE

In the summer of 1974, an article in the journal *Architecture Plus* announced that "Brick-on-Brick and White-on-White: The Walker Art Center May Be the Best Modern Museum in the U.S." Fifteen years later, architecture critic Paul Goldberger, writing for the Sunday *New York Times* on January 29, 1989, pronounced the Minneapolis Sculpture Garden "the finest new outdoor space in the country for displaying sculpture." The superlatives "best" and "finest"—conferred on the Walker's 1971 violet brick building, with its cubelike volumes, flexible white gallery spaces, spiral floor plan, and three rooftop terraces, and on the original 7 1/2-acre design for the Minneapolis Sculpture Garden—belong to architect Edward Larrabee Barnes, who designed both of these acclaimed, art-sensitive spaces. Harvard-trained Barnes had studied under the famed Bauhaus architects Walter Gropius and Marcel Breuer. It was his perceptive adaptations of their minimal, International Style modernism to specific local contexts that led Walker director Martin Friedman to engage his services for the remodeling of T. B. Walker's 1927 building, which by the early 1960s was in great need of structural correction and of expansion to contain the museum's ever-growing collection and programs. Eventually, it was determined that nothing short of a wrecking ball was required, and construction began in 1969 on the building that opened in 1971 to great public and critical acclaim.

When the land directly across from the Walker–Guthrie Theater complex became available for the development of a sculpture garden some years later, it was again Barnes who was engaged to conceive the design, in collaboration with landscape architects Peter Rothschild (who designed the grounds) and Barbara Stauffacher Solomon and Michael Van Valkenburgh (who jointly designed the Regis Gardens in the Conservatory). The formal geometry of Barnes's plan, with its series of adjoining courtyards, was conceived specifically to echo the clear, cubelike architecture of the museum building, but also—ever sensitive to the use to which the spaces would be put—to provide a unique neutral backdrop, devoid of visual clutter, against which to display the works of twentieth-century art to their best advantage.

Barnes drew his inspiration for the southern half of the Garden not from the pastoral nineteenth-century English gardens on which the majority of larger American sculpture parks have been based, but from the broad walkways and intimate hedged enclosures of Renaissance and eighteenth-century Italian gardens, symmetrically ordered and designed to create an idealized experience of the natural setting. Wedding traces of their stately geometry to the clean, spare lines of much of the contemporary sculpture that would be housed there, Barnes conceived a gridded plan for the front half of the garden, composed of four courtyards, each 100 feet square and bordered by dense evergreen hedges planted in low, carnelian granite walls. These "roofless rooms" are the equivalent of the museum's galleries, serene spaces in which visitors can view the works with minimum distraction from the surrounding cityscape.

Separating the four courtyards are two perpendicular, gravel-lined walkways, or *allées,* planted at regular intervals with linden trees. Between the trees, intimate spaces along both sides of the broad avenues provide perfect housings for the smaller-scaled works in bronze or stone that form a part of the Garden's collection. A stroll along the stately north-south axis of this grid, past works by Henry Moore, Isamu Noguchi, and other modern masters, brings the visitor to the northernmost portion of the original Garden site, a broad rectangular field of more informal design, whose undoubted attraction is the free-form pond and monumental *Spoonbridge and Cherry,* commissioned especially for the site from the artists Claes Oldenburg and Coosje van Bruggen. The large open spaces of the field bring the Garden in more direct contact with the urban vistas beyond; here, large-scale sculptures such as David Nash's *Standing Frame* and Sol LeWitt's *X with Columns* interact with the natural and man-made environments that surround them.

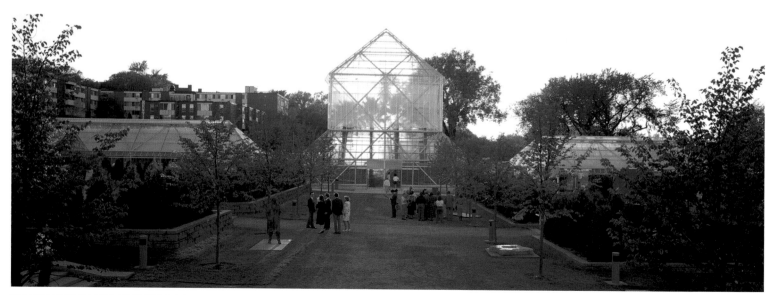

THE EAST-WEST *ALLÉE* LEADS TO THE SAGE AND JOHN COWLES CONSERVATORY

SIAH ARMAJANI'S STUDY FOR THE IRENE HIXON WHITNEY BRIDGE, 1986

At the other end of the axis, near the main entrance to the south, stands Martin Puryear's *Ampersand,* commissioned as a portal to the grounds. Its stately columns frame the Garden beyond, as a series of granite steps invites visitors to descend into its special world. A stroll to each terminus of the east-west *allée* brings the visitor to the other major architectural elements of the Garden. At its eastern bank, a large, curved wall forms an ivied apse, the perfect backdrop for Jacques Lipchitz's inspirational *Prometheus Strangling the Vulture II.* Beyond, Siah Armajani's pedestrian bridge— both a remarkable feat of engineering and a meditative work of art—reunites the Garden with the city's Loring Park and, by extension, with the downtown

areas to the north and east. Joined by a tall, steel gate that is a familiar feature of the artist's work, the bridge's two reversed arches meet at its center in a gesture of alliance between the two spaces, severed for more than twenty years by the intervention of Interstate 94. Dedicated to the memory of Irene Hixon Whitney and her many civic achievements, the bridge joins a long list of Armajani's public art works, including a reading room at the Louis Kahn Institute in Philadelphia, the massive tower for the Olympic torch built for the 1996 games in Atlanta, and a vast collaborative project for Battery Park Plaza in lower Manhattan, conceived together with the sculptor Scott Burton and architect Cesar Pelli.

Directly opposite, at the western end of the walkway, stands the Garden's most prominent architectural feature: the all-glass Sage and John Cowles Conservatory, a veritable "crystal palace" at the grounds' edge. It serves at once as a home for architect Frank Gehry's fantastic leaping glass fish, a space for permanent and rotating horticultural displays, and a sheltered passage for visitors who walk from the parking lot to its northwest on their way to the Walker–Guthrie complex. Designed by Alistair Bevington of the Edward Larrabee Barnes office, the building is constructed of three sections: a 65-foot square central house that rises to a pyramidal apex of the same height, and two adjoining wings, each 82 feet in length. Joining forces to design the Regis Gardens

housed within the Conservatory's interior was a team of two internationally noted landscape architects: Barbara Stauffacher Solomon of San Francisco, subject of the 1982 Walker exhibition *Green Architecture* and author of *Green Architecture and the Agrarian Garden,* and Cambridge-based Michael Van Valkenburgh, professor of landscape architecture at Harvard, author of *Design with the Land,* and creator of projects from a sculpture garden in Seoul, South Korea, to the redesign of the Tuilleries Gardens in Paris. Their conception of the paving, topiary structures, plantings, vine screens, central palm court, and lily pond won the 1989 Honor Award from the American Society of Landscape Architects.

Exploring the idea of architecture as landscape and landscape as architecture, in the north house the pair created a series of four symmetrical "green" arches that follow the structure of the greenhouse itself. The stainless-steel superstructures of the arches were covered with a hydroponic medium (more than 34 variations of soil mix were tested) that is fed by a hydraulic system and planted with a sheathing of creeping fig. In the south house, five pairs of vertical stainless-steel vine scrims support changing displays of climbing plants. Between the architectural elements of both wings, beds containing seasonal displays of flowering plants welcome visitors throughout the year.

When at last the Garden reclaimed the land to its north, Van Valkenburgh and his firm, Michael Van Valkenburgh Associates, were called in to design the extension to the Garden, expanding its grounds by about one-third to encompass eleven or so acres in all. On the 3.7-acre site, Van Valkenburgh created a plan far less formal in design and yet in complete harmony with the original site. The Black Hills spruce that edged the original space were removed and replanted at the new border of the Garden, along Dunwoody Boulevard to the north, and a new entrance was created to link the spaces to the downtown area beyond. An "N" of walkways traverses the grounds, with a long, gracefully curving central path linking the "old" garden to the "new." Groves of deciduous trees along the way, with sculptures sited in the glades and clearings among them, provide contrast to the year-long green of the existing spruce and arborvitae.

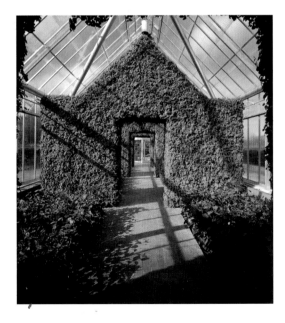

LEFT TO RIGHT: VINE SCRIMS IN THE CONSERVATORY'S SOUTH HOUSE; PLAN FOR THE REGIS GARDENS; GREEN ARCHES IN THE NORTH HOUSE

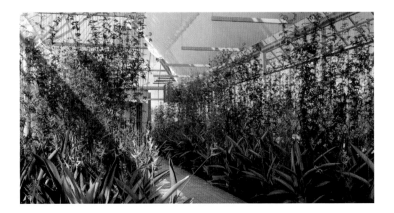

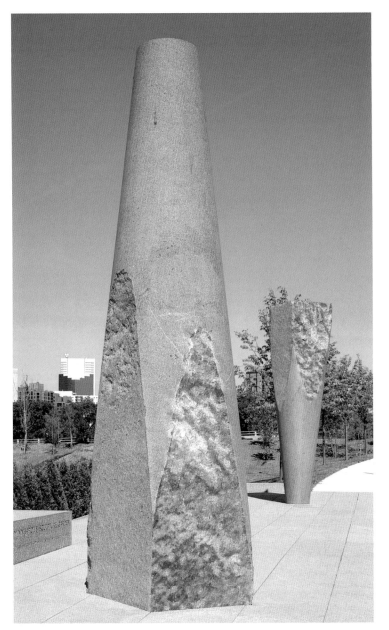

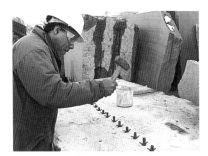

MARTIN PURYEAR AT THE COLD SPRING
GRANITE COMPANY, 1987

MARTIN PURYEAR

AMERICAN, *1941–*

AMPERSAND 1987–1988

GRANITE
EAST COLUMN: 163 x 36 x 36 IN.
WEST COLUMN: 167 x 36 x 38 IN.
GIFT OF MARGARET AND ANGUS WURTELE, 1988

The stately pair of 14-foot stone columns that flank the main entrance
to the Garden at its southern end were fashioned from a huge block
of granite Martin Puryear found at the Cold Spring quarries, 75 miles
northwest of Minneapolis. Puryear drove spikes into the massive stone to
split it in two, and then used a machine lathe—like a pencil sharpener—
to hone each piece into its final form. One end of each column retains
the block shape and rough natural surfaces of the original stone, while
the other end has been shaped into a smooth, elegantly tapered conical
form. Similar contrasts of form and surface appear throughout Puryear's
work, in which such opposites as nature and culture, the organic and
the machine-made, and primitive and modern coexist in harmony.
By installing the columns in opposite directions—one on its pointed
end, the other on its square base—Puryear also comments on the
contrast between stability and instability and offers an intentional
challenge to the formal symmetry of the southern half of the Garden.

2

JENE HIGHSTEIN
AMERICAN, *1942–*

UNTITLED 1987–1988

GRANITE
THREE ELEMENTS: 108 X 48 X 28 IN.; 75 X 61 X 43 IN.; 30 X 90 X 51 IN.
ACQUIRED WITH FUNDS PROVIDED BY MARTHA AND JOHN GABBERT, JOANNE AND PHILIP VON BLON,
AND THE NATIONAL ENDOWMENT FOR THE ARTS, 1989

Jene Highstein studied philosophy, painting, and drawing before turning to sculpture in the late 1960s, applying cement over steel frames to create the large, rounded shapes—mounds and spheres—that interested him. When he finally began to carve in stone around 1980, he was able to explore new aspects of these forms. The three massive monoliths that form the work in the Minneapolis Sculpture Garden were shaped from Pennsylvania granite, scored with a diamond-tipped circular saw, and then chiseled to expose the crystalline structure of the stone. Although they might at first appear to be objects found in nature, primitive totems arranged by tribal worshipers, or even meteors cast from the skies, they are, in fact, carefully crafted works intended to provoke a range of associations regarding nature and culture.

JACKIE FERRARA

AMERICAN, *1929–*

BELVEDERE 1988

CEDAR
126 X 506 X 407 IN.
GIFT OF THE BUTLER FAMILY FOUNDATION, 1988

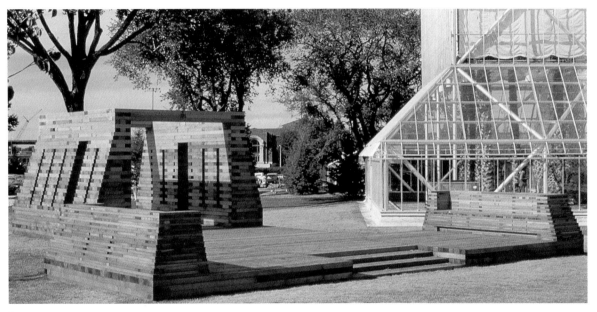

3

A belvedere—"beautiful view" in Italian—is a structure built to command a view of its surroundings. Jackie Ferrara's stylized architectural work for the Garden holds court in the southwest corner of the grounds, where it serves as a reception, performance, and seating area for visitors as well as an object of contemplation. Ferrara's sculptures, whether tabletop sized or of grander scale, are exquisitely crafted meditations on timeless architectural forms. Here, the pylons laid out on a T-shaped floor plan suggest an Egyptian temple. The solid, elemental geometry of the piece contrasts with the delicacy of its surfaces, where complex patterns emerge from the varying lengths and shades of wood and from the play of light and shadow that embellishes the interior spaces.

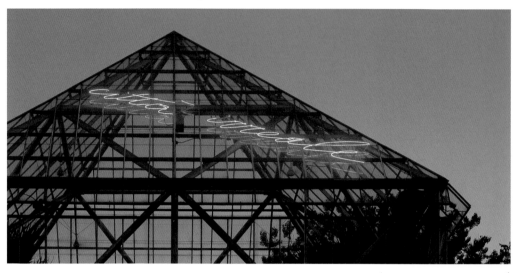

4

MARIO MERZ
ITALIAN, *1925–*

UNTITLED 1996–1997

NEON, GLASS TUBING
240 X 480 IN.
ANONYMOUS GIFT FROM THREE LOCAL RESIDENTS WITH APPRECIATION FOR THE
MINNEAPOLIS SCULPTURE GARDEN AND CONTEMPORARY ART, 1996

INSTALLATION VIEW AT WALKER ART
CENTER, 1972

Mario Merz is a leading artist of *Arte Povera*, a movement that emerged in Italy in the late 1960s among a group of artists dedicated to using the materials of everyday life and the natural world in their work. Igloos (made of such materials as glass, slate, or wax), spirals, the nature-related mathematical formula known as the Fibonacci sequence, and the elemental gas neon are recurring elements in Merz's art, often appearing in combination with one another. Political or literary references in neon script span the domes of his glass igloos, while the Fibonacci numbers (again in neon) spiral up the stairways of museums, as they did here at the Walker Art Center during his first American show in 1972. In the untitled piece the artist created for the Minneapolis Sculpture Garden, the words *città irreale* ("unreal city," a phrase from T. S. Eliot's poem *The Waste Land*) appear in spiraling red neon script on the side of the Cowles Conservatory, disappearing into the glass structure when the piece is unlit.

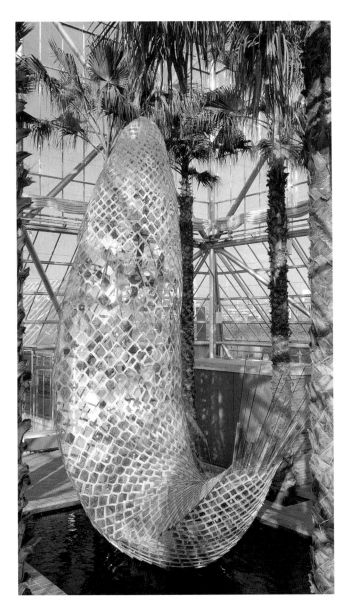

Ever since visitors watched its miraculous birth in the Walker's lobby—pieced together scale by scale by artisans for the exhibition of Frank Gehry's work here in 1986—the *Standing Glass Fish* has become a beloved icon in the city's cultural life. The 22-foot creature waited two years before being carefully disassembled and transported across the street to its permanent habitat: a fantastic lily pond among the Mexican fan palms and calamondin orange trees of the crystalline Cowles Conservatory.

One of the most innovative architects practicing today, Gehry is known for using ordinary materials such as raw plywood and chain-link fencing in his boldly artistic designs. The new Guggenheim Museum in Bilbao, Spain, and the striking Frederick R. Weisman Art Museum here in Minneapolis are two recent examples of his unique architectural vision. The figure of the fish—a fond remembrance of the giant carp his Jewish grandmother would leave swimming in the bathtub each week to use for her Friday-night gefilte fish—has been a recurring motif in Gehry's work. He has used it for his whimsical lamps, in the design for a conference room, and as a notational element in his architectural drawings.

FRANK GEHRY
AMERICAN (BORN IN CANADA), *1929–*

STANDING GLASS FISH 1986

WOOD, GLASS, STEEL, SILICONE, PLEXIGLAS, RUBBER
264 X 168 X 102 IN.
GIFT OF ANNE PIERCE ROGERS IN HONOR OF HER
GRANDCHILDREN, ANNE AND WILL ROGERS, 1986

DAN GRAHAM
AMERICAN, *1942–*

TWO-WAY MIRROR PUNCHED STEEL
HEDGE LABYRINTH 1994–1996

STAINLESS STEEL, GLASS, ARBORVITAE
508 X 206⁵/₁₆ X 90 IN. OVERALL
GIFT OF JUDY AND KENNETH DAYTON, 1996

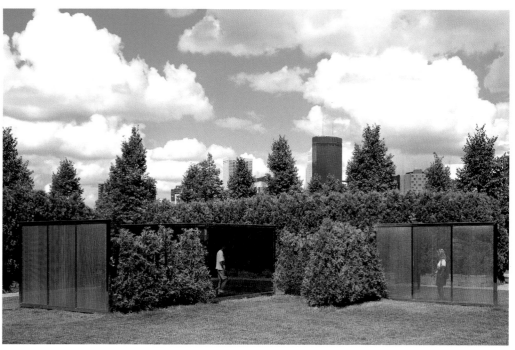

6

Since the mid-1960s, conceptual artist Dan Graham has been investigating how spaces affect human behavior, how art and audiences are connected, and how works of art are linked to their physical, social, and economic contexts. His works have included color photographs of suburban tract homes; interactive performances, films, and video installations; and glass and mirror pavilions, which he has been making for more than twenty years. For the Minneapolis Sculpture Garden he has created a large geometric maze with walls that provide both transparent and reflective surfaces. As we interact with the sculpture we both see and are seen, view the surrounding environment and our own reflections. The piece conjures up questions about inside and outside, about public and private spaces, and—as the reflective surfaces respond to the motion of clouds and sun—about nature and culture.

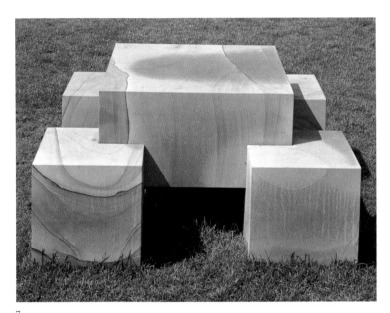

As a performance artist in the early 1970s, Scott Burton combined "found" body movements with props such as chairs, which he situated on the stage in place of actors. As he turned to sculpture, Burton continued to explore the everyday world, designing objects that are at once utilitarian and highly aesthetic. Consciously drawing on the earlier twentieth-century traditions of De Stijl and Bauhaus design, his "furniture" sculptures are severely minimal, functional forms. They are made, however, with traditional sculptural materials and processes. The sandstone table in the Garden is supported by four cubic blocks that double as both legs and seats. Burton's art was meant to provide a direct means of social engagement. Indeed, visitors may explore this curious table by contemplating its form and possible uses or by using its "legs" as chairs on which to rest and view the surrounding sights.

SCOTT BURTON

AMERICAN, *1939–1989*

SEAT-LEG TABLE 1986/1991

SANDSTONE
28¹/₂ X 56 X 56 IN.
GIFT OF HONEYWELL INC. IN HONOR OF
HARRIET AND EDSON W. SPENCER, 1992

TONY SMITH

AMERICAN, *1912–1980*

AMARYLLIS 1965/1968

COR-TEN STEEL, PAINT
138 x 90 x 138 IN.
GIFT OF THE T. B. WALKER FOUNDATION, 1968

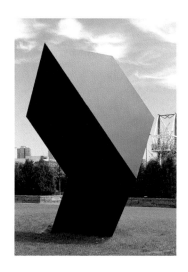

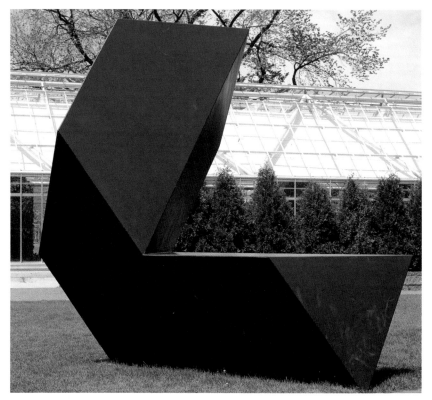

8

Tony Smith had worked as an apprentice to Frank Lloyd Wright and was a practicing architect, designer, and painter for twenty years before turning to sculpture around 1960. Creating his monochromatic works in steel out of simple geometric forms, Smith influenced the development of Minimal sculpture—which values rational order, conceptual rigor, and clarity over expressive values and content. *Amaryllis,* composed of two polyhedron shapes, changes dramatically as the viewer circles it. From one perspective the two shapes appear identical and balanced; from the side view the entire structure seems ready to topple. Smith titled this work *Amaryllis* because the piece at first appeared rather ungainly to him, just as the amaryllis plant seemed "some terrible aberration of form."

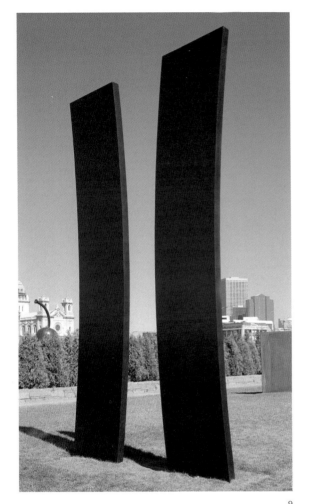

9

ELLSWORTH KELLY

AMERICAN, *1923–*

DOUBLE CURVE 1988

BRONZE
TWO ELEMENTS: 216 x 40 x 4½ IN. EACH
GIFT OF JUDY AND KENNETH DAYTON, 1988

While Ellsworth Kelly is perhaps best known for his abstract paintings—canvases with sharply delineated areas of bold, flat color laid out in pure geometric shapes—the sculptures he has made throughout his career explore many of the same issues regarding form and space. The two 18-foot, gently curving bronze arcs of *Double Curve* are insistently two-dimensional (viewed from the side, they almost disappear). Like the flat shapes in his paintings, they depend on their precisely controlled relationship to each other and to the surrounding area for their impact and surprising complexity. Viewing the surfaces themselves—rich brown in the morning light, stark black silhouettes in the midday sun—the arcs seem to be bending toward one another; viewing the shapes between or around the arcs, a new vibrancy of space, in rhythm with the surrounding landscape, emerges.

RICHARD SERRA

AMERICAN, 1939–

FIVE PLATES, TWO POLES 1971

COR-TEN STEEL
96 X 276 X 216 IN.
GIFT OF JUDY AND KENNETH DAYTON, 1984

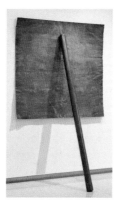

PROP, 1968
GIFT OF PENNY AND
MIKE WINTON, 1977

The title of Richard Serra's massive work in the Minneapolis Sculpture Garden succinctly describes the elements of its construction: two poles along the ground prop up five enormous flat plates of Cor-Ten steel. It is up to the viewer, circling around this essentially two-sided work, to discover the precarious balance of its forms (which seem to defy gravity but, in fact, are perfectly stable) and the dynamic interplay of line, space, and silhouette that are created by its composition. Serra has been exploring the properties of mass and gravity in sculpture since the late 1960s. In an early work in the Walker's own collection, for example, a 60-inch-square sheet of lead is designed to be held flat against the wall and three feet off the ground solely by means of a lead pole that leans against it. Like the best Minimalist art, Serra's sculptures, in spite of their seeming austerity, engage the viewer in intimate acts of discovery.

Louise Bourgeois has been working out formal and emotional issues in her unique body of sculpture for more than fifty years. This work in the Garden was cast in bronze from a painted wood sculpture of the same title, from the late 1940s. Around that time, Bourgeois had been exhibiting her sticklike, carved wooden sculptures in groupings, exploring almost human relationships among the pieces. In *The Blind Leading the Blind,* she brought seven pairs of these figures together in a single group and bound them at their tops with a lintel. The artist has suggested that the sculpture portrays "people who were fated to be destroyed together." The tapered, leglike forms have a rich resonance in Bourgeois's art and life—from the stilts that support the "Woman-Houses" in her early drawings to her childhood memories of crawling beneath the family table and of reconstructing the damaged legs at the bottoms of frayed tapestries for her parents' restoration business.

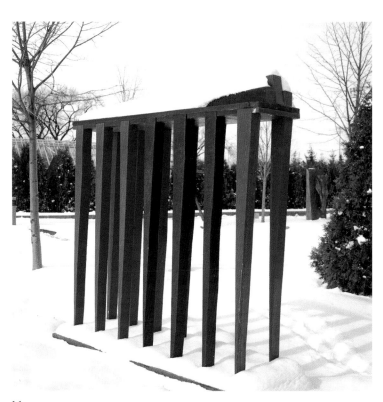

LOUISE BOURGEOIS
AMERICAN (BORN IN FRANCE), *1911–*

THE BLIND LEADING
THE BLIND 1947–1949/1989

BRONZE, PAINT
88 X 65¼ X 16¼ IN.
GIFT OF THE MARBROOK FOUNDATION, MARNEY AND
CONLEY BROOKS, VIRGINIA AND EDWARD BROOKS, JR.,
MARKELL BROOKS, AND CAROL AND CONLEY BROOKS, JR., 1989

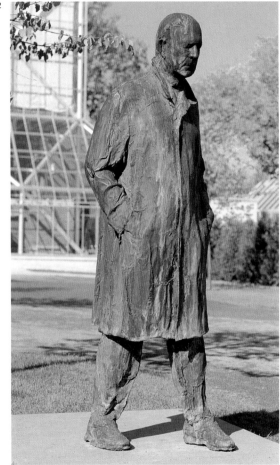

THE DINER, 1964—1966
GIFT OF THE T. B. WALKER FOUNDATION, 1966

The pensive "everyman" George Segal created for the Minneapolis Sculpture Garden was made, like all his sculpture since the 1950s, from a plaster cast formed directly on a real-life model. Segal recast the work in bronze, applied the patina by hand to impart a rich, painterly quality, and placed the figure not on a pedestal, but on a simple fragment of concrete sidewalk near one of the Garden's tree-lined walkways. Here, passing visitors are drawn to this lonely, human-scaled figure. Segal acknowledges that his walking man is linked to a long tradition of striding figures in the history of art, beginning with the Egyptian prototype and "on and on through Rodin and Giacometti." Visitors to the Walker Art Center are well acquainted with one of Segal's famed "situation" sculptures, *The Diner,* in which two of his unpainted plaster figures inhabit the spare confines of a real-life coffee shop. It reminds us of the deep isolation that can accompany our encounters in everyday life.

GEORGE SEGAL

AMERICAN, *1924*—

WALKING MAN 1988

BRONZE
72 X 36 X 30 IN.
GIFT OF THE AT&T FOUNDATION AND THE JULIUS E.
DAVIS FAMILY IN MEMORY OF JULIUS E. DAVIS, 1988

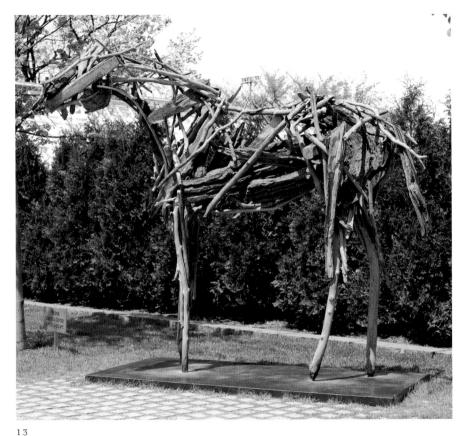

Deborah Butterfield, who owns, rides, and trains horses on her ranch in Montana, has likened the act of "building" a horse through training to the creative process of building her sculptures. Since the early 1970s, Butterfield has been creating magnificently observed, highly individualized horses from a diversity of found materials—fragments of wood, wire, scrap metal, mud, brick dust, and straw. *Woodrow* is something of a technical tour de force. Butterfield took a selection of sticks, tree branches, and bark, cast each element individually in bronze, and then assembled and welded the pieces together to create the stately beast. Each element was then patinated to create the look of the original sticks and branches. The trompe l'oeil effect is so convincing that many visitors to the Garden believe the piece actually is made of wood.

13

DEBORAH BUTTERFIELD

AMERICAN, *1949*–

WOODROW 1988

BRONZE
99 X 105 X 74 IN.
GIFT OF HARRIET AND EDSON W. SPENCER. 1988

KINJI AKAGAWA

AMERICAN (BORN IN JAPAN), *1940–*

GARDEN SEATING, READING, THINKING 1987

GRANITE, BASALT, CEDAR
45 X 144½ X 40 IN.
IN MEMORY OF ELIZABETH DECKER VELIE, 1988

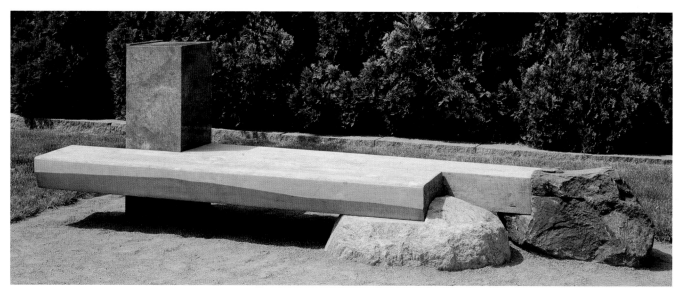

Born in Tokyo and working in Minneapolis since the 1960s, Kinji Akagawa combines the elegant simplicity of Japanese aesthetics with a deep concern for the impact of art on public places. He strives to invite private activities such as reading, thinking, and even writing into the "street" furniture he creates and incorporates common, local materials into their context. The bench he created for the Minneapolis Sculpture Garden combines unfinished green basalt from Minnesota, a vertical base of highly polished granite from South Dakota, and a horizontal slab of cedar that recalls forests from the region's past. The three elements retain their separate and unique characteristics as they combine to create an elegant whole that invites us to rest, read, and reflect in the Garden.

Trained as an art historian, Philip Larson turned to art-making in the early 1970s. In his sculptures and prints, he frequently incorporates geometrical patterns that are inspired by architectural forms—especially the building ornamentation of Chicago and Prairie School architects such as Louis Sullivan and Frank Lloyd Wright. In the bench he designed for the Minneapolis Sculpture Garden, Larson explores progressive permutations of basic geometric forms. The cast-iron components of the piece represent the six possible combinations of four irregular diamond shapes dervied from rock crystals. Larson has also created such public projects as the walkway system for General Mills and the etched-glass transit shelters along Nicollet Mall in downtown Minneapolis.

PHILIP LARSON
AMERICAN, *1944*–

THE SIX CRYSTALS 1988

GRANITE, IRON
18⅜ X 104 X 28 IN.
GIFT OF DR. MICHAEL PAPARELLA, 1988

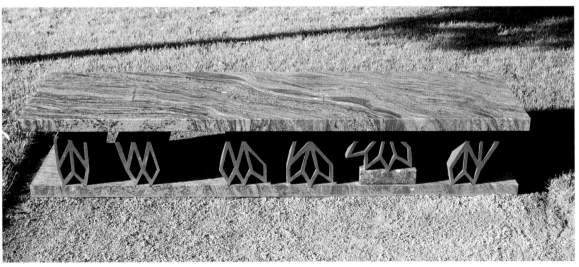

15

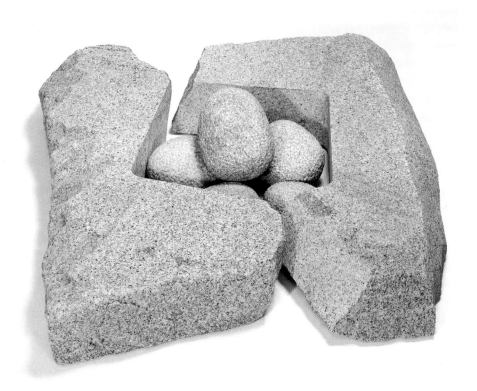

A major figure in American art for more than fifty years, Isamu Noguchi was a master of simple, economical sculptural form and a visionary landscape architect. This work from the later part of his career takes its name from an island off the coast of Japan (literally, "magic island"), from which the granite of this rough-surfaced, low-lying sculpture is thought to have come. Throughout his career, Noguchi had been intrigued by the challenge of using light materials, such as balsa wood and aluminum, to make things that look heavy, and heavy materials, like marble and bronze, to make things that look light. *Shodo Shima*, with the abstract appearance of a giant bird's nest, surely must recall this sculptural paradox: the massive granite forms piled at its center suggest the delicate fragility of birds' eggs.

ISAMU NOGUCHI
AMERICAN, *1904–1988*

SHODO SHIMA STONE STUDY 1978

GRANITE
12 X 66 X 69 IN. OVERALL
GIFT OF THE ARTIST, 1978

LOUISE NEVELSON

AMERICAN (BORN IN UKRAINE), *1900–1988*

DAWN TREE 1976

ALUMINUM, PAINT
103⅝ X 92½ X 62¾ IN.
GIFT OF JUDY AND KENNETH DAYTON, 1998

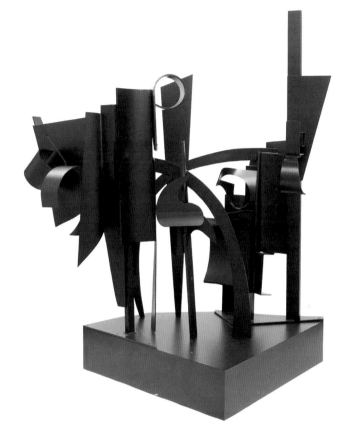

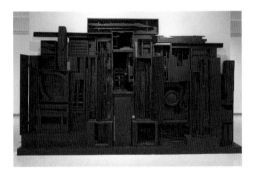

SKY CATHEDRAL PRESENCE, 1951–1964
GIFT OF JUDY AND KENNETH DAYTON, 1969

17

Louise Nevelson's best known and most characteristic works are the mysterious, large-scale wooden "walls" she first began making in the late 1950s. These compartmentalized assemblages of shallow wood crates, crammed with fragments of architectural ornamentation, pieces of cast-off furniture, and other found objects, were painted a uniform, flat black (and, later, white or gold). As suggested by the title of the Walker's own dramatic wall sculpture, *Sky Cathedral Presence*, Nevelson transformed these composites of everyday wooden bric-a-brac into imposing, altarlike presences, infused with mystery. During the 1970s, Nevelson began to make works that were more individually conceived: flowers and trees in welded aluminum. *Dawn Tree* is an example of one of these later works. With its collage of flattened shapes and characteristic black-painted surfaces, it recalls her earlier wall reliefs. Its smaller stature, free-standing orientation, and playful reference to nature make it a fitting addition to the Garden.

REUBEN NAKIAN

AMERICAN, *1897–1987*

This unnamed, archetypal goddess, with her massive, splayed thighs supported on a primitive altar of rough-hewn pillars, is a potent symbol of fertility. According to the artist, she represents "the birth of the universe." Like a number of American sculptors practicing in New York during the 1940s and 1950s, Reuben Nakian worked in a style that paralleled the development of Abstract Expressionist painting. The roughly worked, patinated surfaces of his sculptures and their fragmented, abstract forms mirror the aggressive shapes and textures that the New York School painters achieved in their canvases. Nakian forged a uniquely personal style in his sculpture, inspired by Greek and Roman art and classical mythology.

GODDESS WITH
THE GOLDEN THIGHS 1964–1965/1987

BRONZE
84 x 150 x 42 IN. OVERALL
GIFT OF DOLLY J. FITERMAN, 1987

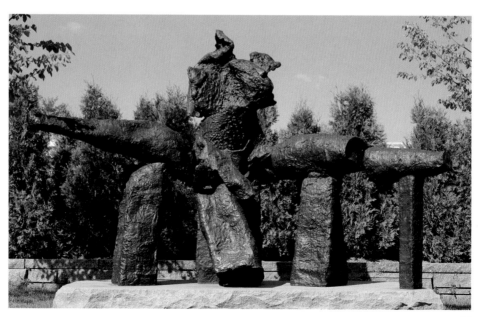

18

HENRY MOORE
BRITISH, *1898–1986*

RECLINING MOTHER AND CHILD 1960–1961

BRONZE
90 X 35½ X 52 IN.
GIFT OF THE T. B. WALKER FOUNDATION, 1963

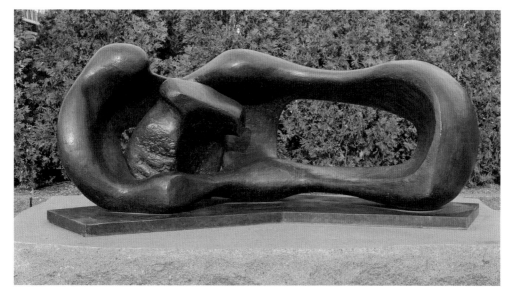

19

The reclining human figure was a central theme in the work of the British sculptor Henry Moore, who used abstract forms to create powerful renderings of the human figure throughout his long and venerable career. In his archetypal organic abstraction in the Minneapolis Sculpture Garden, this fascination with the reclining form is wedded to another of the artist's frequent themes: the mother enclosing her child in a protective embrace. The swelling volumes of the bronze enclose equally evocative empty spaces, recalling at once both human and geological forms: the sensuous curves of the maternal figure, with its womblike cavity, and an analogous landscape of rocks and caves. The materials of Moore's sculptures—carvings in wood and stone in his earlier works, metal casts from clay or plaster forms in his later period—are integral to his explorations of subject matter. Here, he carved numerous hatchings and striations into the original plaster before casting it in bronze and gave further detail to the surface in the carefully applied patina.

MARINO MARINI

ITALIAN, *1901–1980*

CAVALIERE (HORSEMAN) CIRCA 1949

BRONZE
70⅝ X 45½ X 32 IN.
GIFT OF THE T. B. WALKER FOUNDATION, 1953

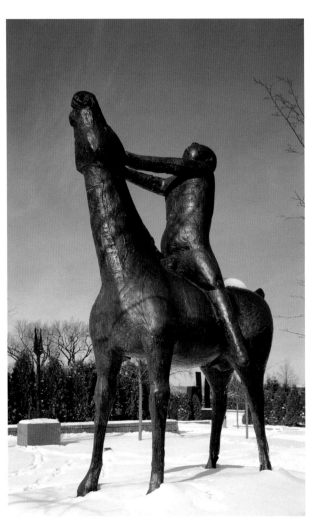

The principal subject of Marino Marini's sculpture, beginning in the 1930s and continuing throughout his long career, was the heroic theme of horse and rider. His equestrian statues evolved over the years from formal versions in the classical style, inspired by Roman and Etruscan art, to fiercely personal visions in which the rider, increasingly unable to control his mount, came to represent the human condition itself. As Marini put it: "My equestrian statues express the torment caused by the events of this century. . . . My wish is to reveal the final moment of the dissolution of a myth, the myth of the heroic individual, the humanists' 'man of virtue.'"

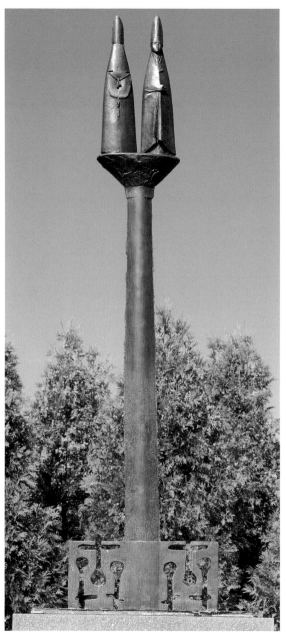

GIACOMO MANZÙ
ITALIAN, *1908–1991*

LA GRANDE CHIAVE
(THE LARGE KEY) 1959

BRONZE
96¹⁄₂ X 36 X 14³⁄₄ IN.
ANONYMOUS GIFT, 1963

The sculptures of Giacomo Manzù are largely religious in their
themes, and their graceful proportions derive from the principles
of classical art. Manzù was commissioned to create the fifth door
of Saint Peter's Basilica in Rome. Entitled *The Door of Death* (1962),
it was dedicated to the Pope, who is shown kneeling in prayer
in one of the lower panels. The heavenward-directed prongs of
The Large Key are actually two tall-hatted bronze cardinals,
one facing forward, the other backward—an enigmatic statement
of the omnipresence of the Roman Catholic Church in Italian life.

GEORG KOLBE
GERMAN, *1877–1947*

JUNGE FRAU
(YOUNG WOMAN) 1926

BRONZE
50⅝ X 14⅝ X 12¼ IN.
GIFT OF THE T. B. WALKER FOUNDATION, 1958

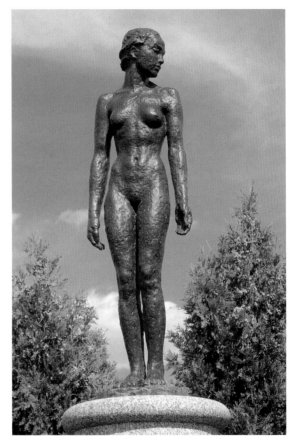

22

The idealized, modern nymph who graces the Garden's central walkway, known as the "bronze *allée*," recalls the garden traditions of the eighteenth and nineteenth centuries. Georg Kolbe, who began sculpting at the beginning of this century, brought the traditions of neoclassicism to the sculpture of his day and was particularly inspired by the work of Auguste Rodin. The lyrical grace of this piece from the mid-1920s represents a highpoint in his mature style. Although some of his sculptures were banned during the Nazi era, he continued to work, but in a more acceptable, heroic style that never again achieved the rhythmic beauty of such earlier works as this one.

Nike, in Greek mythology, was the goddess of victory who aided Zeus in his battle against the Titans. Often depicted as a winged figure, we know her best as the *Nike of Samothrace* (or *Winged Victory*), one of the finest examples of Hellenistic sculpture and a highlight of the Louvre Museum in Paris. Saul Baizerman's academic training—in Russia as a young man and later at the Beaux Arts Institute in New York—introduced him to such mythological themes and to the idealized human figures of classical sculpture, which he explored extensively in his mature work. Subtly molding his forms from huge sheets of copper, he reinterpreted these beings in the stylized, sleek "moderne" sensibility of the 1950s. The copper fabricating process allowed Baizerman to endow his figures with an immediacy and vitality that he felt unable to attain in bronze. Indeed, this *Nike* seems nearly ready to rise up in flight.

SAUL BAIZERMAN

AMERICAN (BORN IN RUSSIA), *1889–1957*

NIKE 1949–1952

COPPER
67½ X 21½ X 18 IN.
GIFT OF THE T. B. WALKER FOUNDATION, 1953

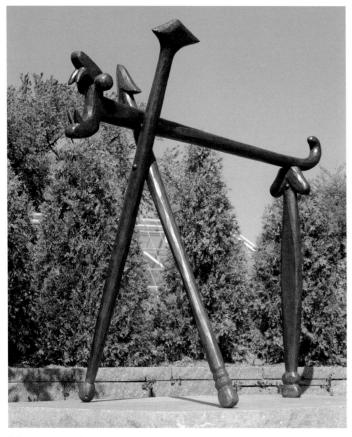

24

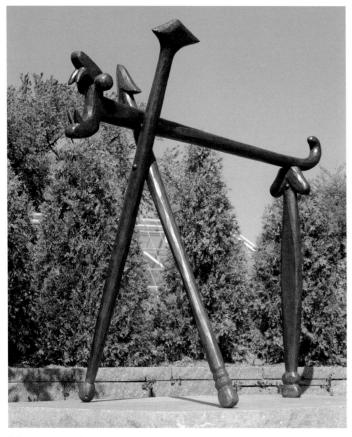

MARTHA GRAHAM, 1950
PHOTO: CRIS ALEXANDER

In the years after World War II, Isamu Noguchi designed stage sets and costumes for the most advanced choreographers of the day: Martha Graham, Merce Cunningham, and George Balanchine. This sculpture was originally an element of the stage design for Graham's 1950 *Judith*, a dramatization in dance of the Old Testament story in which the Hebrew widow saves Jerusalem by seducing the dreaded invader Holofernes and beheading him in his own bed. The structure in the Garden—originally made of balsa wood and recast by Noguchi in bronze nearly thirty years later—was covered with one of Graham's signature flowing cloths to form a tent at the moment of the dramatic deed. The fragile balance of the sculpture's four skeletal, weaponlike elements imparts the tense excitement of the story's dangerous scheme and recalls other of the artist's gravity-defying sculptures of the period. His 1947 pieces *Avatar* and *Cronos*, also in the Walker's permanent collection, are similar assemblages of slender elements joined together in an intricate system of balance.

ISAMU NOGUCHI
AMERICAN, *1904–1988*

THEATER SET PIECE FROM JUDITH 1950/1978

BRONZE
108 x 109 x 54 IN. OVERALL
PURCHASED WITH THE AID OF FUNDS FROM THE ART CENTER ACQUISITION FUND
AND THE NATIONAL ENDOWMENT FOR THE ARTS, 1978

HENRY MOORE

BRITISH, *1898–1986*

STANDING FIGURE: KNIFE EDGE 1961

BRONZE
111 X 45½ X 24 IN.
GIFT OF DAYTON'S, 1987

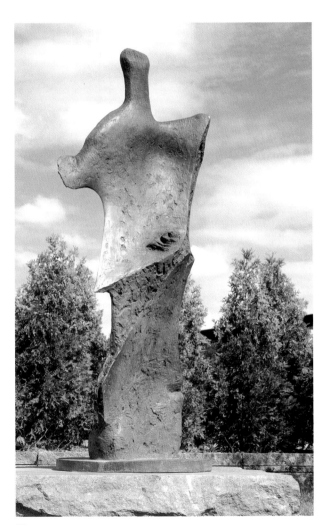

Henry Moore once titled this standing figure *Winged Victory*.
With her truncated arms and neck and elongated, protruding torso,
she indeed recalls the famed Greek figure of that name. But the
real inspiration for this creature was the breastbone of a bird.
Moore discovered principles of form and rhythm for his sculptures
in a variety of natural objects, such as rocks and plants. He had a
particular fascination with bones and collected, studied, and drew
them extensively to explore their complexity and dynamism.
He incorporated the actual bird bone into an early maquette for
this sculpture, eventually infusing its "knife-edge thinness"
throughout the entire figure and retaining the rough, porous
texture of bone in the work's bronze surface. Viewed from
differing perspectives, the sculpture appears alternately razor
sharp or rhythmically curvaceous.

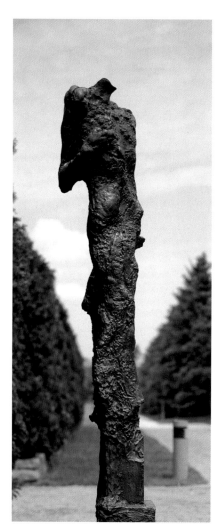

JONATHAN SILVER

AMERICAN, *1937–1992*

WOUNDED AMAZON 1982–1983

BRONZE
85 X 21 X 16 IN.
GIFT OF SIDNEY SINGER, 1987

New York sculptor Jonathan Silver was known for his figurative
sculptures, classical forms infused with an intensely modern sense
of emotion. Silver created exaggerated, fragmented figures that
were greatly influenced by the sculpture of Rodin and by Giacometti,
whose "stick" men possess a similar elemental and primitive force.
The abstract, headless torso in the Garden depicts an Amazon,
a member of the race of mythological Greek warrior women who
excluded men from their society. The name *Amazon* itself is
Greek for "breastless," since, according to legend, it was the practice
of these women archers to burn off their right breasts in order
to pull back their bows more effectively. Never, however, was this
disfiguration depicted in the ancient images of the beautiful
warriors on temple friezes and vases. Silver's Amazon, by contrast,
has been wounded. Although proud in stature, the roughened,
flayed surfaces of her skin suggest the frightening mutilation of myth
and the ravages earned from a life of battle.

Richard Stankiewicz lived next to a scrap yard when he was a child and often made toys for himself from the random materials he found there. After studying painting in New York and sculpture in Paris, Stankiewicz returned to "junk" in 1951, creating the first of his welded steel sculptures from pieces of scrap metal he unearthed while converting his back yard into a garden. During the 1950s, Stankiewicz assembled fragments of old boiler tanks, chains, wire, machine parts, and other discarded metal objects into bizarre, often humorous "people." Turning to more formal, abstract forms in the 1960s, he eventually abandoned junk in favor of prefabricated industrial components such as plate steel, I-beams, angle irons, and pipe. Shortly before his death in 1983, the artist began to reintroduce both found materials and representation into his works. In this piece in the Garden, the last large-scale sculpture he produced, Stankiewicz welded together hoops and pipes to create an elegantly linear form that suggests a giant, weedy tuft of grass.

UNTITLED, 1962
ART CENTER ACQUISITION FUND, 1963

RICHARD STANKIEWICZ

AMERICAN, *1922–1983*

GRASS 1980–1981

STEEL
151 X 104 X 37 IN.
GIFT OF JUDY AND KENNETH DAYTON, 1988

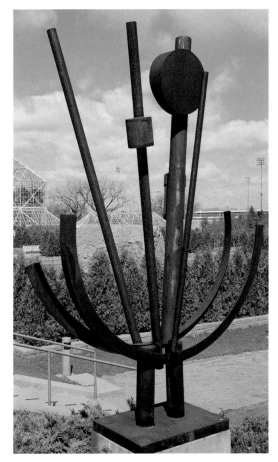

JACQUES LIPCHITZ

AMERICAN (BORN IN LITHUANIA), *1891–1973*

PROMETHEUS STRANGLING THE VULTURE II 1944/1953

BRONZE
91³/₄ X 90 X 57 IN.
GIFT OF THE T. B. WALKER FOUNDATION, 1956

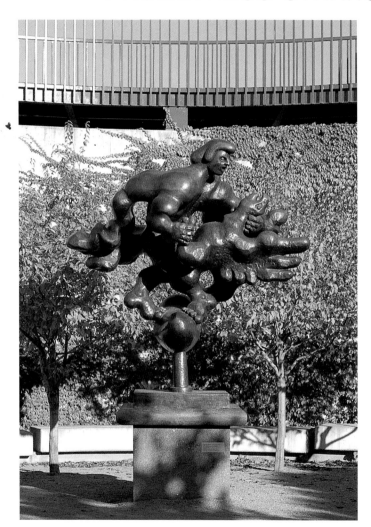

When Lithuanian-born sculptor Jacques Lipchitz emigrated to Paris in 1909, his friendship with the Spanish artists Juan Gris and Pablo Picasso led him to explore Cubism in his sculptures. By the late 1920s, however, Lipchitz moved from these figures made of flat planes and angular masses to a looser style based on natural forms, and he began to explore themes and ideas in his sculptures rather than purely formal relationships. The theme of Prometheus emerged as early as 1933 in his work, as a symbol of human progress and determination and a parable for the triumph of democracy over fascism. In the Greek legend, Prometheus stole fire from the gods and bestowed it as a gift on humankind. This so enraged the god Zeus that he had Prometheus chained to a rocky mountainside, to be tortured by a vulture for all eternity. In Lipchitz's sculptural version of the story, however, Prometheus triumphs over his fate: freed from his chains, he strangles the bird with one hand as he grips the claws in the other. The original version of *Prometheus Strangling the Vulture* was a 30-foot work cast in plaster for the 1937 International Exhibition in Paris. After the artist resettled in America, the Brazilian government commissioned him to sculpt another Prometheus for the Ministry of Education and Health building in Rio de Janeiro. The Walker sculpture is based on this 1944 version, which was recast in bronze in 1953.

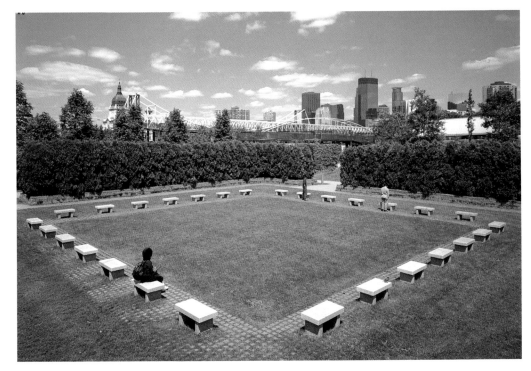

29

Onto each of the twenty-eight white granite benches arranged symmetrically around the perimeter of a square, Jenny Holzer has engraved a different aphorism. Since the mid-1970s, using words as her artistic medium, Holzer has been disseminating her provocative messages—"truisms"—into public spaces: on posters, on stickers placed on parking meters or telephone booths, on electronic display signboards from Times Square to Caesar's Palace, and most recently, on the Internet. As the first woman artist to represent the United States at the prestigious Venice Biennale in 1990, Holzer created a memorable installation of twenty-one electronic signboards flashing messages in a babel of languages. Her sculptural installation in the Garden allows visitors a place to rest as they contemplate her cryptic, often contradictory, messages and the role that language plays in contemporary society.

JENNY HOLZER

AMERICAN, *1950–*

SELECTIONS FROM
THE LIVING SERIES 1989

GRANITE
TWENTY-EIGHT ELEMENTS: 17¼ X 36 X 18 IN. EACH
ANONYMOUS GIFT FROM A LOCAL RESIDENT WITH
APPRECIATION FOR THE MINNEAPOLIS SCULPTURE GARDEN
AND CONTEMPORARY ART, 1993

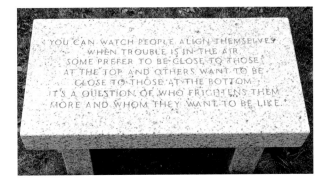

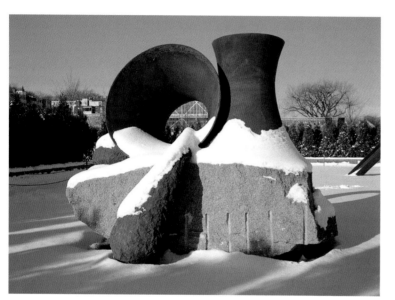

Trained as a scientist, Tony Cragg creates art that investigates the natural world. Yet if his sculptures comment on such topics as molecular structure, the human vascular system, or the Newtonian light spectrum, it is his use of man-made forms (either found or constructed) that transforms them into complex meditations on contemporary life. Here Cragg has constructed steel elements on a granite base—two smooth-surfaced concave cylindrical forms and two elemental biomorphic shapes—that comment on the Ordovician geological era of 500 million years ago, when oxygen was introduced into the atmosphere. While the oxygen gave rise to terrestrial life, it simultaneously killed off the species of algae that had produced it. The close resemblance of the cylinders to the cooling towers of nuclear power plants perhaps suggests an analogous life-death conundrum for our own technological age.

30

TONY CRAGG

BRITISH, *1949–*

ORDOVICIAN PORE 1989

GRANITE, STEEL
96 X 90 X 124 IN. OVERALL
GIFT OF JOANNE AND PHILIP VON BLON, 1989

MARK DI SUVERO

AMERICAN (BORN IN CHINA), *1933–*

ARIKIDEA 1977–1982

COR-TEN STEEL, STEEL, WOOD
316½ X 510 X 450 IN.
GIFT OF JUDY AND KENNETH DAYTON, 1985

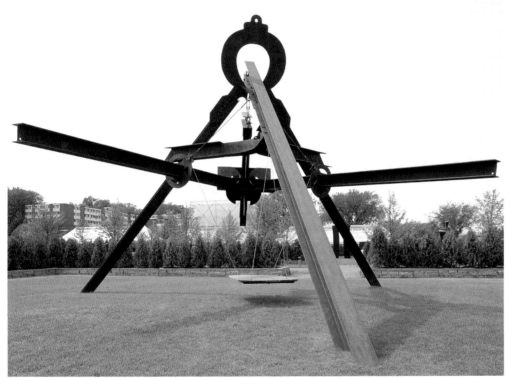

31

MARK DI SUVERO ASSEMBLING
ARIKIDEA, 1987

More than 26 feet high and 42 feet wide, and weighing in at approximately three tons, Mark di Suvero's *Arikidea* is certainly deserving of the description "monumental." Yet this massive structure belies an ingeniously constructed delicacy. The gigantic steel beams have been masterfully balanced in such a way that a simple touch or a passing breeze will cause the structure to sway gently. The wooden swing suspended from its center playfully invites the viewer to further interact with the work, moving into and through its airy spaces. Beginning in the late 1950s, di Suvero drew on the gestural ideas of Abstract Expressionist painting, extending them into the three-dimensional realm of sculpture. His early cantilevered constructions of junkyard detritus (old tires, scrap metal, steel girders) later gave way to the massive, outdoor steel sculptures for which he is known today. The title of this piece evolved loosely from the word *arachnid,* Greek for "spider," a creature di Suvero admired for its capacity to create structures in space.

BARRY FLANAGAN

BRITISH (BORN IN WALES), *1941–*

HARE ON BELL ON PORTLAND STONE PIERS 1983

BRONZE, LIMESTONE
102 x 112 x 75 IN.
GIFT OF ANNE LARSEN SIMONSON AND
GLEN AND MARILYN NELSON, 1987

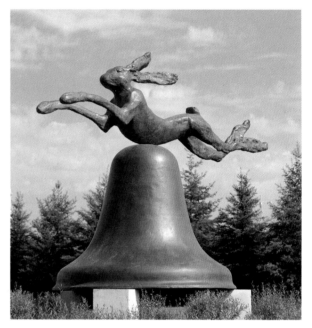

32

Throughout his career, Barry Flanagan has been challenging the status quo in sculpture. As a student in London in the 1960s, when other artists were using industrial methods and materials, Flanagan began shaping such unorthodox substances as sand, burlap, felt, and plastic into ephemeral shapes, focusing on the process of artmaking rather than the finished, permanent object. In the late 1970s and early 1980s, by contrast, when figurative sculpture was hardly the norm, Flanagan began making representational images (hares, helmets, and horses) using surprisingly traditional materials and processes: lost-wax bronze casting, gilding, stone carving. Here, an exuberant, bounding hare balances atop a classically formed bell, providing an interesting study in contrasts. The sinuous lines and playful vitality of the hare counter-balance the elegant formality of the bell, which evokes centuries of the bronze-casting tradition. The novel juxtaposition of the two forms—both symbols of fertility and both frequent motifs in Flanagan's art—conjures up new and fantastic associations.

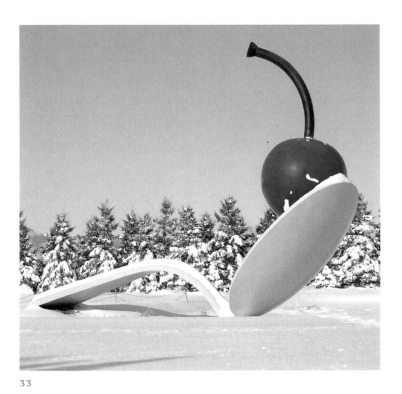

Claes Oldenburg is best known for his ingenious, oversized renditions of ordinary objects, like the giant "soft" three-way plug and overturned bag of french fries in the Walker's own collection. He and Coosje van Bruggen, his wife and collaborator, had already created a number of large-scale public sculptures, including the *Batcolumn* in Chicago, when they were asked to design a fountain-sculpture for the planned Minneapolis Sculpture Garden. The spoon had appeared as a motif in a number of Oldenburg's drawings and plans over the years, inspired by a novelty item (a spoon resting on a glob of fake chocolate) he had acquired in 1962. Eventually the utensil emerged—in humorously gigantic scale—as the theme of the Minneapolis project. Van Bruggen contributed the cherry as a playful reference to the Garden's formal geometry, which reminded her of Versailles and the exaggerated dining etiquette Louis XIV imposed there. She also conceived the pond's shape in the form of a linden seed. (Linden trees are planted along the *allées* that stretch before the fountain.) The complex fabrication of the 5,800 pound spoon and 1,200 pound cherry was carried out at two shipbuilding yards in New England. The sculpture has become a beloved icon in the Garden, whether glacéed with snow in the Minnesota winters or gleaming in the warmer months, with water flowing over the surface of the cherry and a fine mist rising from its stem.

CLAES OLDENBURG
AMERICAN (BORN IN SWEDEN), *1929–*

COOSJE VAN BRUGGEN
DUTCH, *1942–*

SPOONBRIDGE AND CHERRY 1985–1988

ALUMINUM, STAINLESS STEEL, PAINT
354 X 618 X 162 IN.
GIFT OF FREDERICK R. WEISMAN IN HONOR OF HIS PARENTS,
WILLIAM AND MARY WEISMAN, 1988

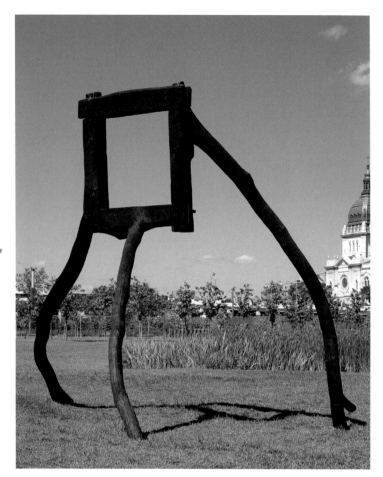

DAVID NASH

BRITISH, *1945–*

STANDING FRAME 1987

CHARRED WHITE OAK
172 x 209¾ x 209½ IN.
GIFT OF *STAR TRIBUNE* AND COWLES MEDIA FOUNDATION, 1987

CONTRUCTING *STANDING FRAME* AT
TAYLORS FALLS, MINNESOTA, 1987

34

British artist David Nash has been making sculptures from trees since the late 1970s. An ardent environmentalist, he uses only trees that have fallen or cuts fully mature specimens to open space for new growth. He then uses the wood as completely as possible, including the twigs and scraps, which are reduced to charcoal for his drawings. This work for the Garden was made from two white oaks found near Taylors Falls, Minnesota. Nash fashioned the stripped branches and trunk into an open square frame supported on three "legs," its sections joined in tongue-and-groove fashion and secured with wooden pegs. The resulting structure allows visitors to frame idealized views of the surrounding land and cityscape, reminding us of the role art can play in unifying man and nature. In 1994, after the wood's natural aging had turned the sculpture a pale gray, Nash charred its surface with a propane torch to embolden its sculptural line and provide a new seal.

ALEXANDER CALDER

AMERICAN, *1898–1976*

BLACK FLAG 1974

STEEL, PAINT
237 x 188 IN.
LONG-TERM LOAN COURTESY
ESTATE OF ALEXANDER CALDER
AND PACEWILDENSTEIN

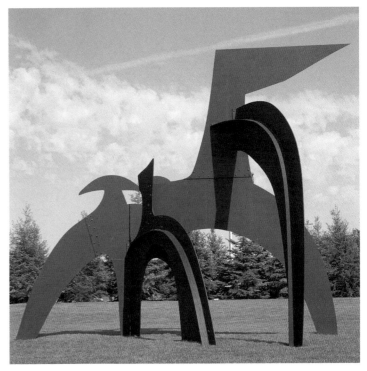

35

THE SPINNER, 1966
GIFT OF DAYTON HUDSON
CORPORATION, 1971

Alexander Calder created some of the century's best known sculptures, which inhabit public spaces in major cities around the world. The son of a sculptor himself and trained in engineering, Calder traveled to Paris in the 1920s, where he became known for his wire sculptures, especially a series of delightful miniature circus figures. Inspired by artists such as Piet Mondrian, Joan Miró, and Jean Arp, he began to experiment with abstraction in the 1930s, at the same time charting a major breakthrough in sculpture: the introduction of motion. His "mobiles" are delicately balanced constructions of abstractly shaped metal plates, rods, and wires that change continuously as the various points of balance respond to the breeze or a touch. By contrast, in the 1950s and 1960s, Calder began to create monumental stationary pieces—"stabiles"—made of flat plates of metal cut into abstract shapes, painted black, and bolted, ribbed, and gusseted together in self-supporting configurations. *Black Flag* supports itself on a series of massive arches, at times appearing like a giant cutout creature about to lope off through the surrounding spaces.

CHARLES GINNEVER

AMERICAN, *1931–*

NAUTILUS 1976

COR-TEN STEEL
APPROX. 132 x 264 x 408 IN.; DIMENSIONS VARIABLE WITH INSTALLATION
ACQUIRED WITH FUNDS FROM DR. AND MRS. JOHN S. JACOBY IN MEMORY OF JOHN DIXON JACOBY,
SUZANNE WALKER AND THOMAS N. GILMORE, THE ART CENTER ACQUISITION FUND,
AND THE NATIONAL ENDOWMENT FOR THE ARTS, 1976

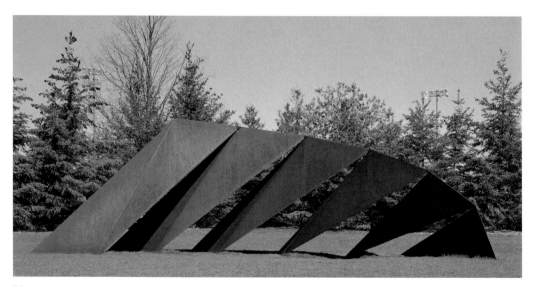

36

The design for Charles Ginnever's mammoth steel sculpture was inspired by one of nature's unique primitive structures: the spiraling, chambered shell of the marine mollusk known as the nautilus. Like Richard Serra's *Five Plates, Two Poles,* also constructed from massive plates of industrial Cor-Ten steel, the sculpture's seemingly precarious balance merely suggests impending collapse. To understand its spatially complex form the viewer must circle around the piece, tracing the spiral motion of the progressively sized chambers to discover the secret of its design: six flat parallelograms, folded at regularly increasing intervals, that are welded together. Ginnever got the idea for folding flat sheets into a three-dimensional object—abstract yet suggesting a real figure—from Japanese origami, the decorative art of cut-and-folded paper. The changing light and seasons interact with the sculpture's surfaces to create subtly shifting visual effects.

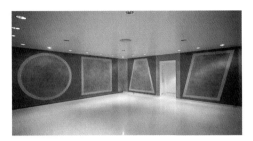

FOUR GEOMETRIC FIGURES IN A ROOM, 1984
COMMISSIONED BY THE ART CENTER WITH FUNDS
PROVIDED BY MR. AND MRS. JULIUS E. DAVIS, 1984

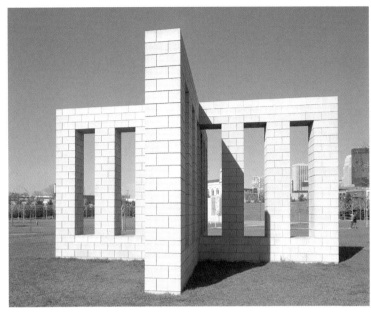

SOL LEWITT

AMERICAN, *1928–*

X WITH COLUMNS 1996

CINDER BLOCK, CONCRETE
168 x 312 x 312 IN.
PARTIAL GIFT OF THE ARTIST WITH FUNDS PROVIDED BY THE JUDY AND KENNETH DAYTON
GARDEN FUND; MATERIALS PROVIDED BY ANCHOR BLOCK COMPANY, 1996

Conceptual artist Sol LeWitt has been well known since the 1960s for his sculpture, graphics, and wall drawings. An example of his cubic, modular sculpture is installed on the Walker's roof terrace, and his *Four Geometric Figures in a Room* can be seen on the walls of the museum's lower lobby. Concepts or ideas are the basic materials of LeWitt's art, which often exists as a set of detailed instructions. As with a musical score or architectural blueprint, the realization of the final work is relegated to others. LeWitt uses the most neutral of materials—here, commercial cinder blocks—and rigorously deploys them in basic geometric configurations. Both the materials and forms he uses intentionally lack any expressive qualities in themselves. They are rather like "grammatical devices" in language, which take on significance only through their combination with one another in actual use. Like David Nash's *Standing Frame*, LeWitt's *X with Columns* provides frames through which views of the surrounding landscape are visible.

Brower Hatcher was trained in engineering and industrial design before he turned to sculpture in the early 1970s. In his stone and steel-mesh sculpture for the Garden, he melds the logic of an engineer with a visionary's impulse to transcend time and space. A futuristic dome, composed of thousands of flexible wire polyhedrons, rests atop six mock-Egyptian columns in a blend of ancient and modern architectural styles. Embedded within the structure and seeming to hover in space are an assortment of common objects and abstract forms: a table, a ladder, a chair, a turtle (whose patterned shell recalls the gridded structure of the dome), random letters, numbers, discs, and dashes. Hatcher offers up these private symbols for universal interpretation, as viewers are inspired to construct their own meanings from the galaxy of images suspended above them.

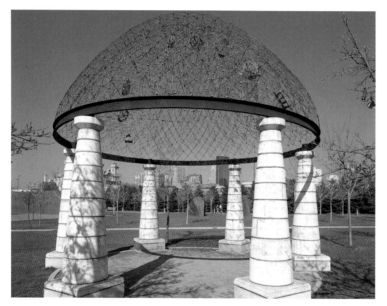

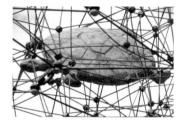

38

BROWER HATCHER
AMERICAN, 1942–

PROPHECY OF THE ANCIENTS 1988

CAST STONE, STAINLESS STEEL, STEEL, BRONZE, ALUMINUM, CERAMIC
HEIGHT: 202 IN.; DIAMETER: 246 IN.
GIFT OF THE LILLY FAMILY, 1989

JUDITH SHEA

AMERICAN, *1948–*

WITHOUT WORDS 1988

BRONZE, MARBLE, LIMESTONE
78 x 80 x 118 IN. OVERALL
GIFT OF JEANNE AND RICHARD LEVITT, 1988

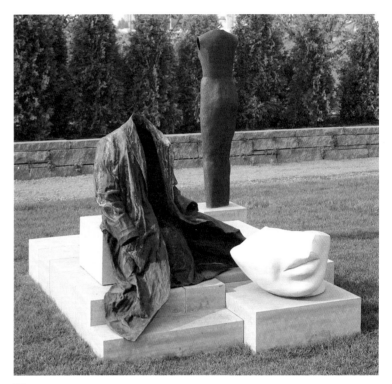

39

Throughout her work, Judith Shea has used clothing to explore the nature and history of sculpture.
Trained as a fashion designer, she soon found that field too restrictive and abandoned it in favor
of sculpture, using clothes at first as abstract forms and, later, as surrogates for the human presence itself.
By the mid-1980s, she began to place her figures into groups, suggesting psychological relationships
among them and the possibility of a story. The three symbolic presences of *Without Words* are a rumpled
raincoat, a spare and elegant dress, and the fragment of a classically molded head. This haunting trio
seems to be carrying on a dialogue about modern life and antiquity. The head was based on an Egyptian
Eighteenth Dynasty sculpture of Queen Tiye; the dress is reminiscent both of archaic Greek statuary
and the sleek couture of the 1950s; the coat is modern, yet recalls the flowing drapery of classical sculpture.

MARK DI SUVERO

AMERICAN (BORN IN CHINA), *1933–*

MOLECULE 1977–1983

STEEL, PAINT
HEIGHT: 456 IN.
GIFT OF HONEYWELL INC. IN HONOR OF HARRIET AND EDSON W. SPENCER, 1991

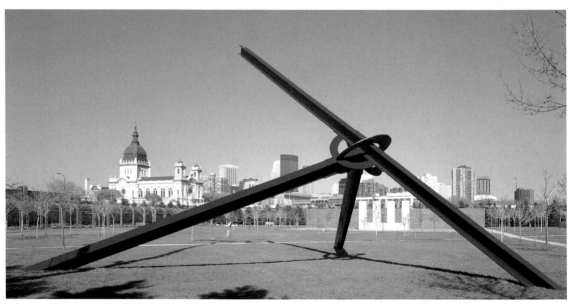

40

The monumental scale and sweeping gestures of this red-painted sculpture are characteristic of the enormous outdoor structures
Mark di Suvero has been making since the 1970s, using cranes to manipulate the massive industrial materials with which he works.
Here, a pair of enormous steel beams meet at their ends, creating a triangular form that tips at an alarmingly improbable angle.
At the point of the beams' juncture are sections of two flat, centerless discs. A longer beam forms the final leg of the tripod, but travels
on some 38 feet into the air, piercing a third disc interwoven with the other two at the point of intersection. The cumulative effect recalls
all the visual and emotive force we attach to the atomic world: dynamic, red-hot, powerful, and strangely elegant. *Molecule,* like all
of di Suvero's large-scale sculptures, invites the viewer to inspect its lines and spaces from every angle.

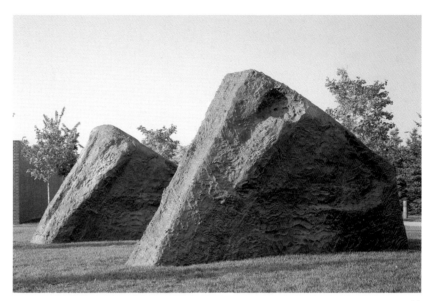

41

MAGDALENA ABAKANOWICZ
POLISH, *1930–*

SAGACIOUS HEAD 6 AND
SAGACIOUS HEAD 7 1989–1990

BRONZE
NO. 6: 98½ X 187 X 108¼ IN.
NO. 7: 101 X 202¾ X 100½ IN.
PURCHASED WITH FUNDS PROVIDED BY THE FREDERICK R. WEISMAN
COLLECTION OF ART, 1992

The two giant, pyramidal bronze forms that Polish artist Magdalena Abakanowicz calls *Sagacious Heads* rise out of the ground like a pair of mysterious beasts or ancient, scarred mountains. For Abakanowicz, known for her haunting groupings of abstracted figures, the head has a special significance: it is "first to see, to react, to inform the whole body," but more importantly, it is "first exposed to the unknown." These featureless heads—silent and mute—have been severed from their bodies and thus from all their responsibilities. Their immutable, enigmatic presence seems to call forth the unknown itself. Abakanowicz fashioned the heads out of Styrofoam, plaster, and fabric, working the soft surfaces of the plaster with her fingers and scoring the Styrofoam with a knife to create the roughened, hidelike textures of the final forms, cast in bronze. The two heads in the Garden are the last in a series of seven the artist executed between 1987 and 1990. Abakanowicz also created a group of ten monolithic bronze "dragon heads" for the Olympic Park at the 1988 games in Seoul, South Korea.

SIAH ARMAJANI

AMERICAN (BORN IN IRAN), *1939–*

IRENE HIXON WHITNEY BRIDGE 1988

STEEL, WOOD, PAINT, CONCRETE, BRASS
LENGTH: 379 FT.
GIFT OF THE MINNEAPOLIS FOUNDATION/IRENE HIXON WHITNEY FAMILY FOUNDER-ADVISOR FUND,
THE PERSEPHONE FOUNDATION, AND WHEELOCK WHITNEY, WITH ADDITIONAL SUPPORT AND SERVICES
FROM THE FEDERAL HIGHWAY ADMINISTRATION, THE MINNESOTA DEPARTMENT OF TRANSPORTATION,
THE CITY OF MINNEAPOLIS, AND THE NATIONAL ENDOWMENT FOR THE ARTS, 1988

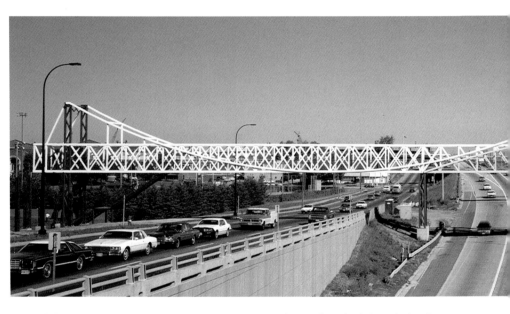

Twin Cities—based artist Siah Armajani is known for his pioneering public works, which have helped to redefine the social function of art both in this country and abroad. More than simply art for public spaces, Armajani's bridges, plazas, and other public art pieces—at once utilitarian and symbolic—are intended to reflect the ideals of a democratic society and to foster discourse and learning in the communities they inhabit.

Armajani explored the bridge as a metaphor for passage in a number of his early conceptual models and works. In 1970, for example, for the exhibition *9 Artists/9 Spaces,* he fashioned an 85-foot-long, rough-timbered wooden bridge. Rising quite surprisingly to a gabled peak at its middle, it sheltered a lone pine tree planted beneath. The idea of passage became decidedly more functional with Armajani's full-scale commission for

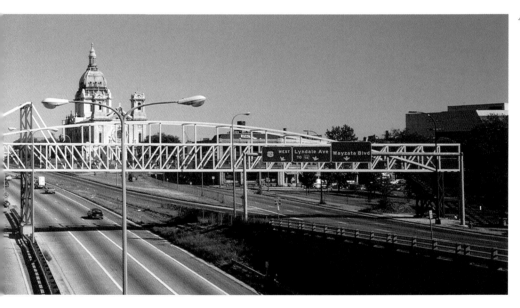

42

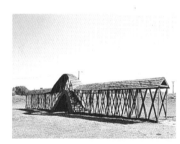

COVERED FOOT BRIDGE (BRIDGE OVER A NICE TRIANGLE TREE), 1970

the Irene Hixon Whitney Bridge, which allows pedestrians to cross the sixteen lanes of streets and highway that had severed the Garden from neighboring Loring Park for many years. The artist's design incorporates the three basic types of bridge structure: beam (across its fir-planked, horizontal span), arch (for the eastern portion), and suspension (for the western portion). To underscore the sense of transition from one part to the next, Armajani painted each half a different, atmospheric shade: pale blue for the upward arching portion and yellow, recreated from the hue that Thomas Jefferson used at his home, Monticello, for the inverted arch. Affixed to the upper lintel of the span and running in each direction across the bridge are the words of a poem—a meditation on movement, place, order, and crossing—which Armajani commissioned specially from the renowned American poet John Ashbery.

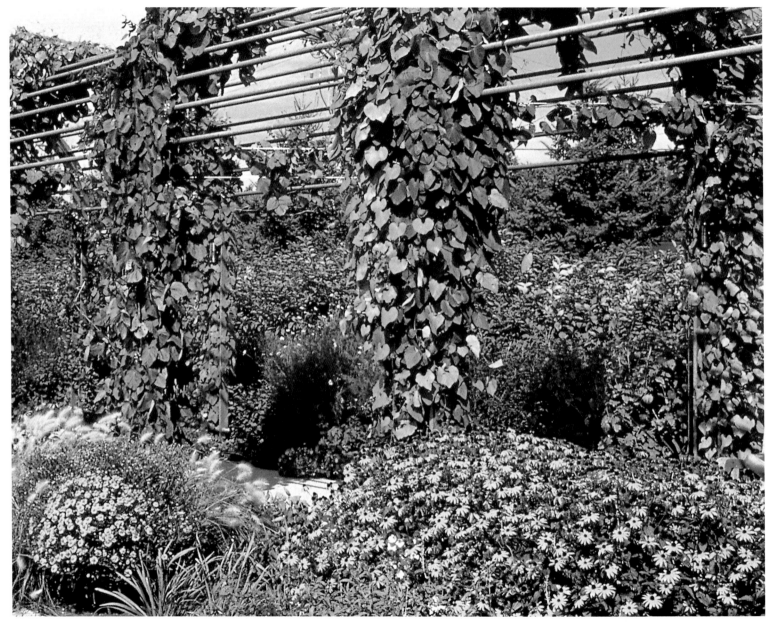

THE ALENE GROSSMAN MEMORIAL ARBOR AND FLOWER GARDEN, DESIGNED BY MICHAEL VAN VALKENBURGH ASSOCIATES

For more than fifty years, the grounds of the Minneapolis Sculpture Garden were home to the city's colorful and popular Armory Gardens, later known as Kenwood Gardens. After their demise in the late 1960s—victim to a massive highway construction project—the land lay fallow for some twenty years. It was only with the building of the Garden, in 1988, that the grounds reclaimed their original horticultural function. Under the careful stewardship of the Minneapolis Park and Recreation Board, they grow more beautiful each year.

The eleven acres of the Garden are home to a broad array of plantings, carefully chosen by some of the nation's most preeminent landscape designers both to complement the works of art and to provide a year-round display of colors, textures, and shapes. The plantings for the southern portion of the Garden, on 7.5 acres, were designed by New York landscape architect Peter Rothschild, whose projects have included the restoration plan for the southeast quadrant of Central Park in New York City. In this part of the Garden, arborvitae form a dense wall of greenery enclosing each of the four front quadrants. The surrounding granite walls are planted with sedum that creeps from its niches. Linden trees lining the broad *allées* that divide these "roofless rooms" continue to grow toward one another, forming graceful natural arbors along the stately avenues. Surrounding the pond in the central portion of the Garden, just north of this area, colorful sweeps of water-loving vegetation—cattail, wild iris, sweet flag, and arrowhead—offset the gigantic *Spoonbridge and Cherry*. Just to the east, arctic willow surrounds Barry Flanagan's delightful sculpture depicting a nimble hare on a bronze bell.

THE LIVING GARDEN
HORTICULTURAL FEATURES

Inside the linear greenhouses of the Cowles Conservatory are the Regis Gardens, designed by landscape architects Barbara Stauffacher Solomon and Michael Van Valkenburgh. Here, a series of greenery arches and stainless-steel vine scrims provide a living architectural backdrop for the rotating displays of flowers and plants in the beds between: hibiscus, cleome, amaryllis, freesia, or bromeliads, by turn. Each visit brings a new and fragrant surprise throughout the year. In the central court, Frank Gehry's *Standing Glass Fish* leaps from a pool of aquatic plants, surrounded by regal fan palms that rise some sixty feet toward the glass roof above and by orange trees, fragrant with fruit. Viewed from the exterior on a frigid winter day in Minnesota, the crystalline fish and lush tropical vegetation are a sight, indeed, to behold.

The 3.7-acre extension at the north end of the Garden, designed by Michael Van Valkenburgh Associates, is planted with deciduous trees that provide seasonal changes of color and silhouette: hackberry, swamp white oak, and Washington hawthorn. The spectacular Alene Grossman Memorial Arbor and Flower Garden is a living sculpture itself. Red cardinal climber and hyacinth bean sheathe its stainless-steel arches, as clematis and morning glory provide color at moments throughout the summer. Spectacular plantings of sun-loving perennials and annuals—Siberian iris, black-eyed Susan, bee balm, false indigo, candy lily, balloon flower, aster, cosmos, and heliotrope, among others—flank the souther border of the arbor. Shade-tolerant varieties—meadow rue, bleeding heart, astilbe, and more—grace its northern edge. The artful display changes throughout the growing season, as spring, summer, and fall varieties take their places along the 300-foot walk. Behind, a stately wall of Black Hills spruce forms the rear boundary of the Garden.

Selected Plantings

GRANITE PLANTERS	'DARK GREEN' AMERICAN ARBORVITAE (*THUJA OCCIDENTALIS* 'NIGRA') DRAGON'S BLOOD SEDUM (*SEDUM SPURIUM* 'DRAGON'S BLOOD')
GRAVEL ALLÉES	GLENLEVEN LITTLELEAF LINDEN (*TILIA CORDATA* 'GLENLEVEN')
EASTERN APSE WALL	JAPANESE TREE LILAC (*SYRINGA RETICULATA*) BOSTON IVY (*PARTHENOCISSUS TRICUSPIDATA*)
EASTERN BANK	GINKGO (*GINKGO BILOBA*) QUAKING ASPEN (*POPULUS TREMULOIDES*) RED MAPLE (*ACER RUBRUM*)

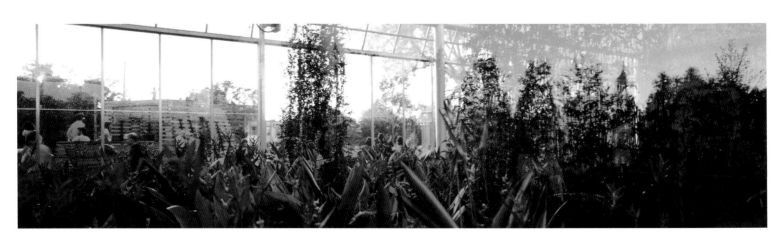

ABOVE: DISPLAY OF HELICONIA AMONG THE VINE SCRIMS *OPPOSITE LEFT:* HELIOTROPE IN THE SOUTH GREENHOUSE *OPPOSITE RIGHT:* PLANTINGS OF CLEOME

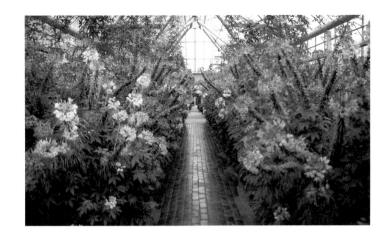

Central Court Eulalia Grass (*Miscanthus sp.*)
Wild Iris (*Iris versicolor*)
Sweet Flag (*Acorus calamus*)
Arrowhead (*Sagittaria latifolia*)
Dwarf Blue Leaf Arctic Willow (*Salix purpurea* 'Nana')

Cowles Conservatory Mexican Fan Palm (*Washingtonia robusta*)
Calamondin Orange Tree (*X Citrofortunella mitis*)
Creeping fig (*Ficus pumila*)

Garden Expansion Hackberry (*Celtis occidentalis*)
Swamp White Oak (*Quercus bicolor*)
Washington Hawthorn (*Crataegus phaenopyrum*)
Black Hills Spruce (*Picea glauca* 'Densata')
Cardinal Red Osier Dogwood (*Cornus sericea* 'Cardinal')

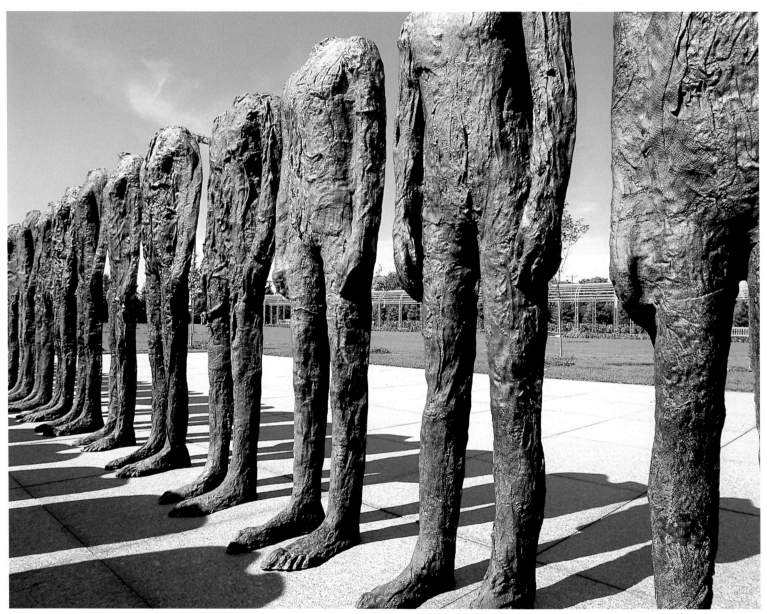

ABOVE: BRONZE FIGURES BY MAGDALENA ABAKANOWICZ ON THE SCULPTURE PLAZA, 1992 *OPPOSITE LEFT:* GALLERY VIEW OF THE EXHIBITION *SCULPTURE INSIDE OUTSIDE,* 1988
OPPOSITE RIGHT: OUTDOOR VIEW OF *SCULPTURE INSIDE OUTSIDE,* WITH MEG WEBSTER'S *GLEN* (1988) IN THE FOREGROUND

SPECIAL ATTRACTIONS

There are more than forty permanent works of art in the Minneapolis Sculpture Garden. From the beginning, the Walker Art Center has been committed to enhancing this collection through temporary exhibitions. Whether focusing on additional works by artists represented in the Garden or presenting new work by other important artists, these special exhibitions provide ongoing educational and artistic opportunities for visitors. They have taken place both inside the museum building, on the Garden grounds, and even off-site, to provide access to more members of the community. Each has brought a new dimension to our understanding of artistic expression, and each brings a changing perspective to the Garden experience.

Sculpture Inside Outside was presented in conjunction with the opening of the Minneapolis Sculpture Garden in 1988. As its title suggests, the show presented works both within the museum's galleries and outdoors on the new Garden site. Some of the sculptures, like those by Martin Puryear, Brower Hatcher, Judith Shea, and Jene Highstein, are permanent fixtures in the Garden today. Additional examples of their work were displayed inside the building, along with that of other important young artists, like Robert Gober, Jin Soo Kim, and Donald Lipski. Inside and outside, seventeen artists were represented in all. Especially memorable was Meg Webster's fascinating "earth" sculpture *Glen,* a grotto-like structure—dense with textures and odors—that was planted on its interior with carefully arranged flowering plants.

The opening of the Garden expansion in 1992 was accompanied by an exhibition that focused on one of the Garden's most beloved artists: Claes Oldenburg, who together with his wife and collaborator Coosje van Bruggen, created the fanciful *Spoonbridge and Cherry* especially for the site. An in-depth examination of Oldenburg's working methods, *Claes Oldenburg: In the Studio* provided visitors with an increased understanding of the artist's ideas and a delightful encounter with his indoor sculptures and drawings. Also on display for the Garden expansion opening was the first exhibit on the new outdoor granite plaza: a mesmerizing grouping of thirty-six bronze figures, headless and aligned in rows, by the Polish artist Magdalena Abakanowicz. This outdoor "gallery" has also been host to the exhibition *Joel Shapiro: Outdoors,* a presentation of this important American sculptor's "figurative" bronze works.

One of the most intriguing projects to have taken place in the Garden was the inside-outside exploration of Belgian artist Mark Luyten, who created installations at the start of each season over the course of two years. His changing displays—collectively titled *On a Balcony*—included fragments of text that were silkscreened or rubber-stamped on the windows of the Cowles Conservatory (where, inside, sheets of glass—each engraved with a word or phrase—grew in a great stack each day); films projected onto the hedges of the Garden's "roofless rooms"; a pile of North Sea shells and a crystal ball that moved from spots around the building into the outdoor spaces; and a "balcony" (actually, a concrete cast of part of the floor in his Antwerp studio) placed on the central path at the entrance to the Garden.

The Garden in the Galleries, presented in 1994, gave visitors a chance to see how the Garden artists have continued their explorations in smaller-scale, indoor works, sometimes in other media. On hand were "fish" lamps by Frank Gehry, videotapes of Scott Burton's performance work, a painting by Ellsworth Kelly, a film by Richard Serra, Siah Armajani's sculpture that doubles as a reading stand, and a new work by local artist Kinji Akagawa. *Wintergarden,* presented in the twelfth-floor gallery at Dayton's department store that same year, brought drawings and models by the Garden artists to downtown visitors. Back in 1988, at its annual Spring Flower Show, Dayton's had been host to a presentation by landscape designers Barbara Stauffacher Solomon and Michael Van Valkenburgh, creators of the Regis Gardens in the Cowles Conservatory. The breathtaking seas of flowers they designed served as a living backdrop to several of the new sculptures—including Barry Flanagan's *Hare on Bell on Portland Piers*—that would be placed in the Minneapolis Sculpture Garden later that fall.

The Walker continues its commitment to exhibitions that expand the Garden's offerings, to commissions of new works, to residencies that bring working artists into the community, and to collaborations with other organizations and institutions around the city. Together with the workshops, performances, readings, and other events that take place among the sculptures, these activities truly have brought the Garden to life.

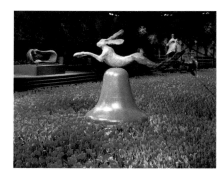

*ABOVE: THE GARDEN IN THE GALLERIES EXHIBITION IN 1994 FEATURED
SIAH ARMAJANI'S DICTIONARY FOR BUILDING: THE GARDEN GATE (1982–1983)
AS WELL AS MODELS, FURNITURE, AND LAMPS BY FRANK GEHRY
LEFT: THE 1988 DAYTON'S SPRING FLOWER SHOW

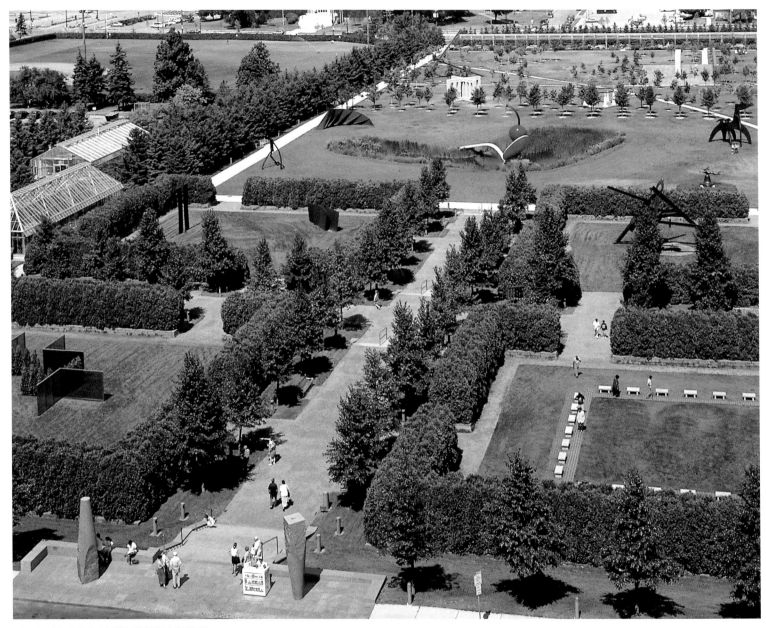

VIEW OF THE MINNEAPOLIS SCULPTURE GARDEN

Garden Donors

The Minneapolis Sculpture Garden was established and operates largely due to generous loans and donations of art, creative services, and financial support from numerous organizations, foundations, and individuals. Their contributions have made the Garden a unique and priceless creation that has given great pleasure to its many visitors. Heartfelt thanks go to:

Acoustic Communication Systems, Inc.
Anchor Block Company
Hugh J. Andersen Foundation
Art Center Acquisition Fund
AT&T Foundation
Carol and Conley Brooks, Jr.
Markell Brooks
Marney and Conley Brooks
Virginia and Edward Brooks, Jr.
The Bush Foundation
Patrick and Aimee Butler Family Foundation
Estate of Alexander Calder
The Cargill Foundation
City of Minneapolis
Linda Coffey
Cold Spring Granite Company
Sage and John Cowles
Dennis Russell Davies
Julius E. Davis family
Judy and Kenneth Dayton
Lucy and Donald Dayton
Mary Lee and Wallace C. Dayton
Dayton Hudson Foundation for Dayton's and Target Stores

Dayton's
Federal Highway Administration
Dolly J. Fiterman
Clarence G. Frame
Martha and John Gabbert
General Mills Foundation
Ann and Gordon Getty
Candyce and David Gray
N. Bud Grossman family
Ann Hatch
Harriet Walker Henderson
Honeywell Foundation
Honeywell Inc.
Dr. and Mrs. John S. Jacoby
Jerome Foundation
Margaret Velie Kinney
The Kresge Foundation
Lannan Foundation
Jeanne and Richard Levitt
Lilly family
Goodrich Lowry
Marbrook Foundation
William and Nadine McGuire
The McKnight Foundation

Donald McNeil

Rudolph W. Miller

The Minneapolis Foundation/Irene Hixon Whitney Family Founder-Advisor Fund

Minnesota Department of Transportation

National Endowment for the Arts

Marilyn and Glen Nelson

Isamu Noguchi

Norwest Foundation

Susan and Richardson Okie

PaceWildenstein

Becky and Michael Paparella

Donald I. Perry

Persephone Foundation

Pilot Foundation

The Regis Foundation

Anne Pierce Rogers

Anne Larsen Simonson

Sidney Singer

Harriet and Edson Spencer

Star Tribune and Cowles Media Foundation

United States Department of Transportation

Joanne and Philip Von Blon

Suzanne Walker and Thomas N. Gilmore

T. B. Walker Foundation

The Andy Warhol Foundation for the Visual Arts, Inc.

Frederick R. Weisman

Marcia Weisman

Helen and J. Kimball Whitney

Wheelock Whitney

Margaret and Angus Wurtele

Ann and Louis Zelle

anonymous donors